Masterpieces of

Romney

(1910)

ISBN-13 : 978-1512353013
ISBN-10 : 1512353019

Copyright©2012-2014 Iacob Adrian
All Rights Reserved.

Notice

This documentary study use historic, archived documents.

Because of this, some pages may look blurry or low quality.

Still are included in this book because they have

high value from critical, documentary, historical,

informative and journalistic point of view .

Dtp and visual art

Iacob Adrian

THE MASTERPIECES

OF

ROMNEY

(1734-1802)

*Sixty reproductions of photographs from the original paintings,
affording examples of the different characteristics
of the Artist's work*

Author statement

This is a series of art books.

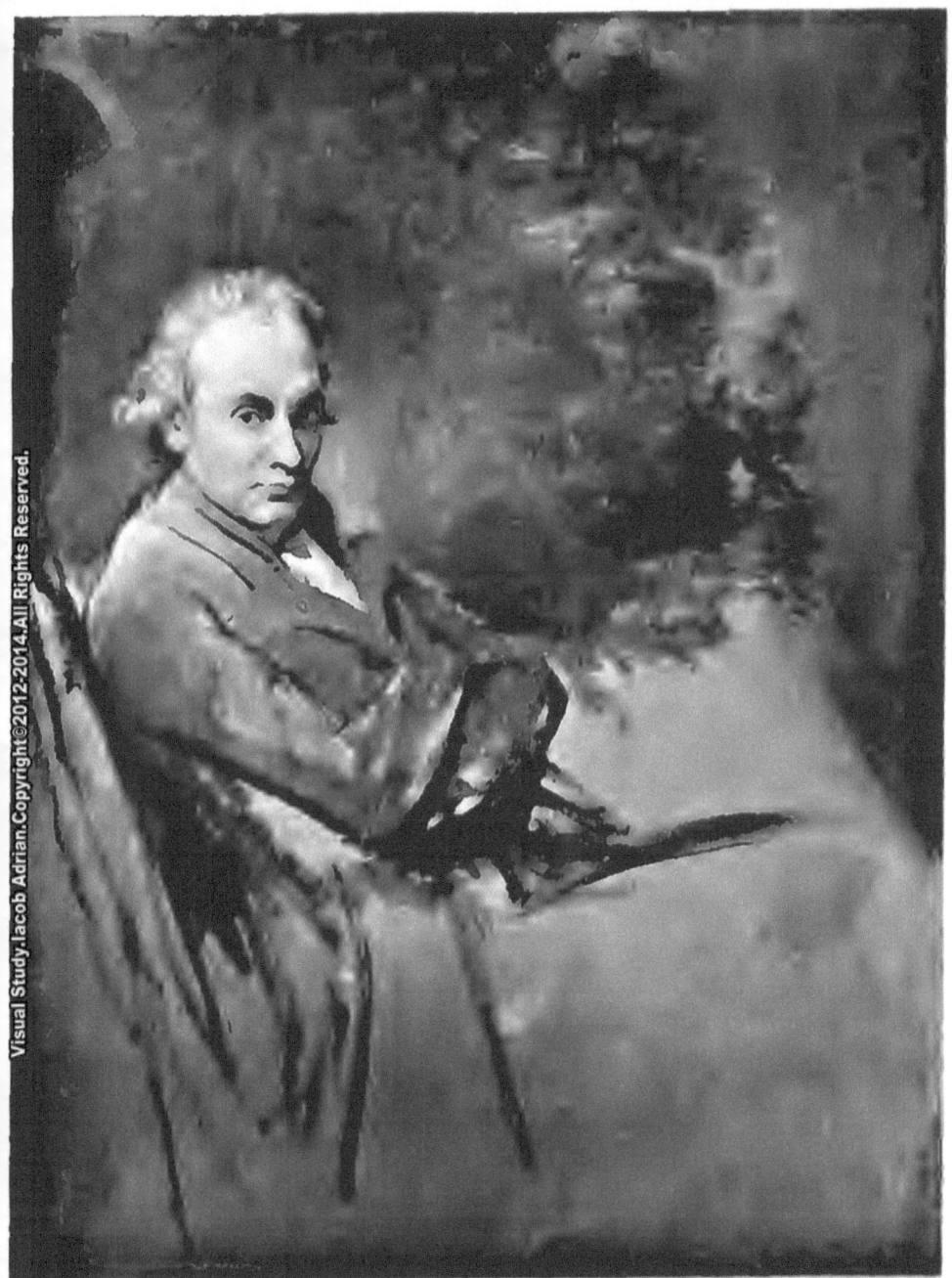

PORTRAIT OF THE ARTIST
(Unfinished)

PORTRAIT DE L'ARTISTE
(Inachevé)

SELBSTBILDNIS (Unbeendet)
(*National Portrait Gallery, London*)
W. A. Mansell & Co., Photo.

This little Book conveys the greetings of

..

to

..

―――――――――――――――

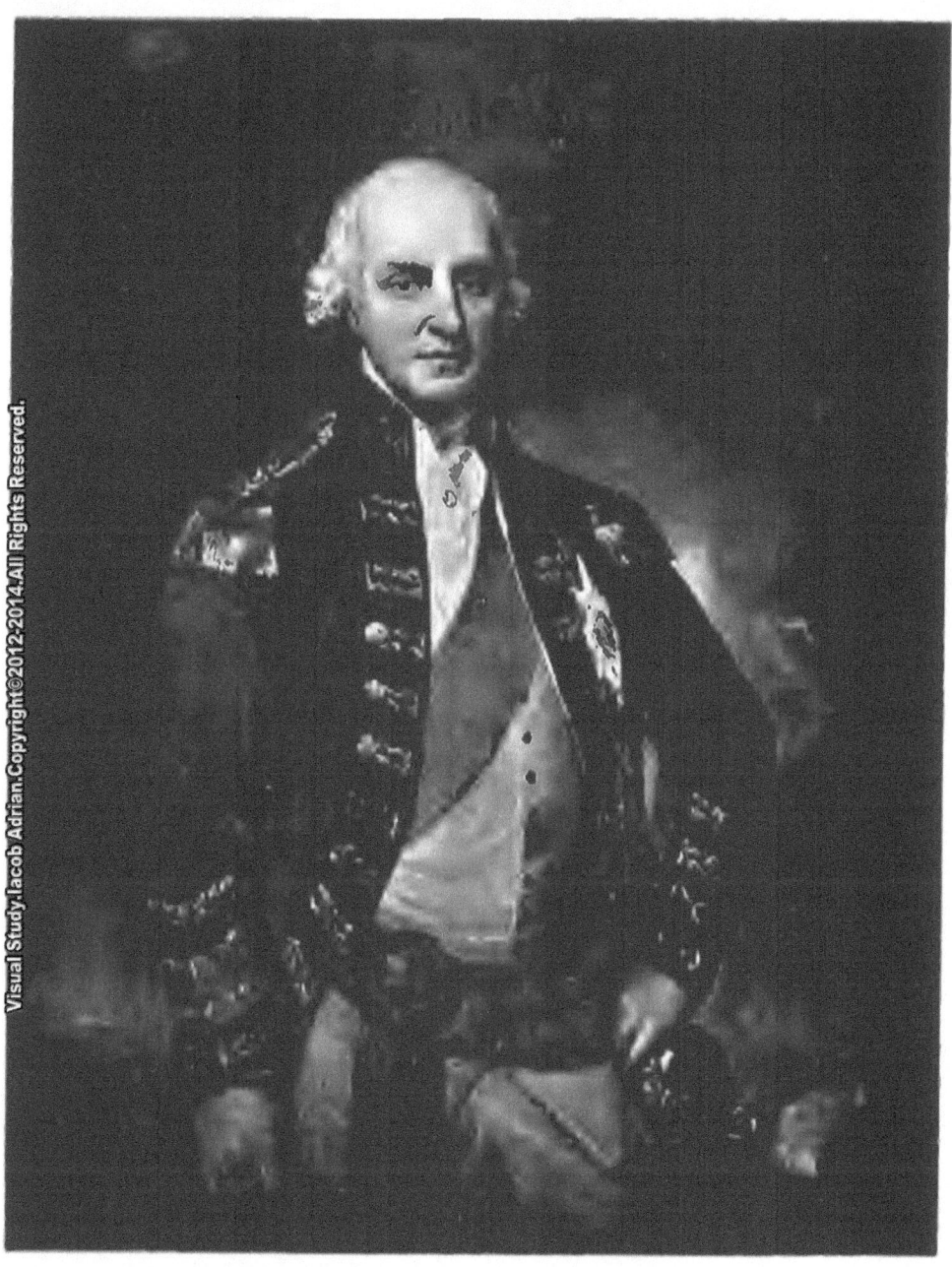

CHARLES, 3RD DUKE OF RICHMOND
(*Duke of Richmond and Gordon, Goodwood*)
W. A. Mansell & Co., Photo.

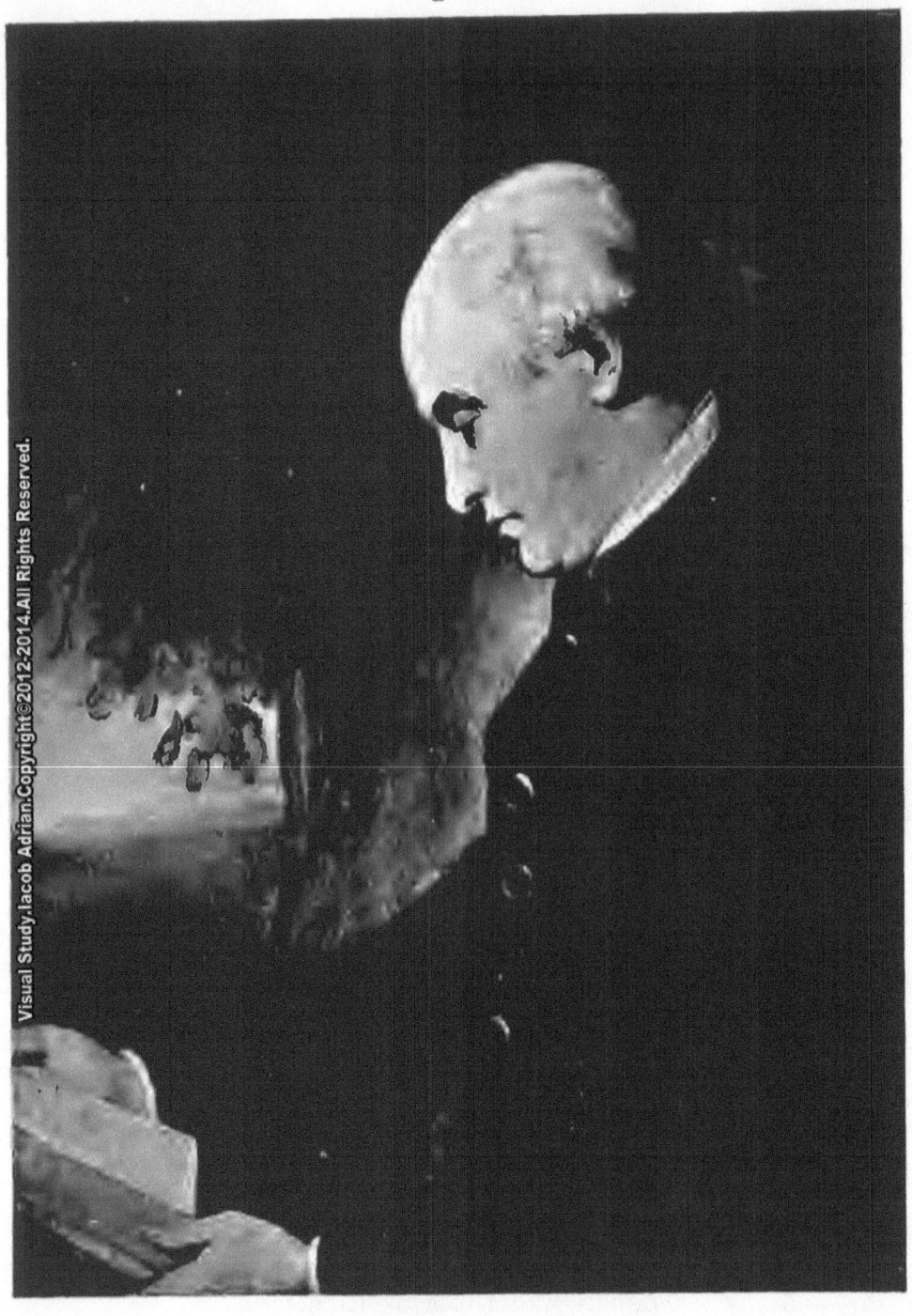

CHARLES, 3RD DUKE OF RICHMOND
(*Duke of Richmond and Gordon, Goodwood*)
W. A. Mansell & Co., Photo.

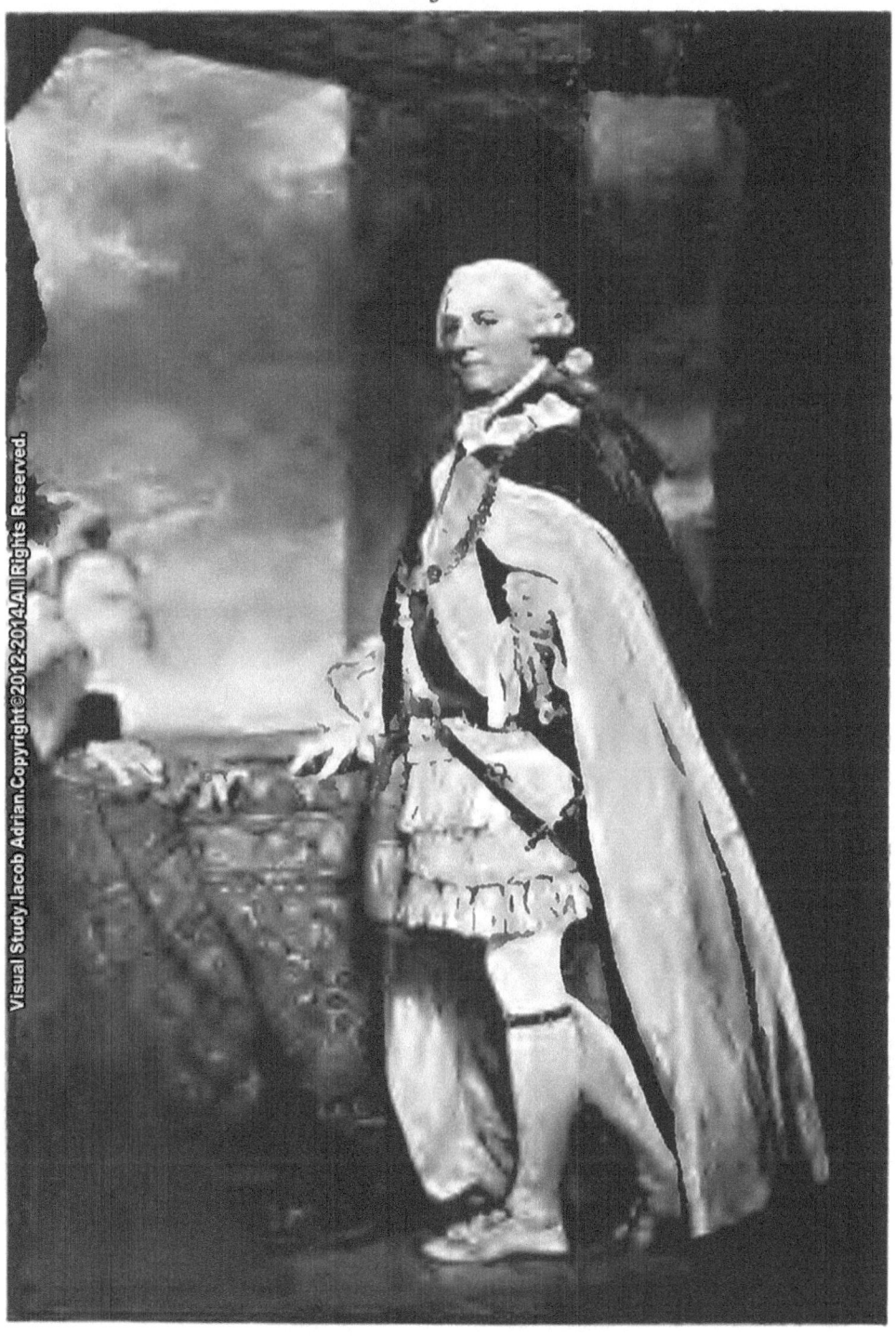

EARL GOWER (1ST MARQUESS OF STAFFORD)
(*Duke of Sutherland, London*)
E. Harrison & Son, Photo.

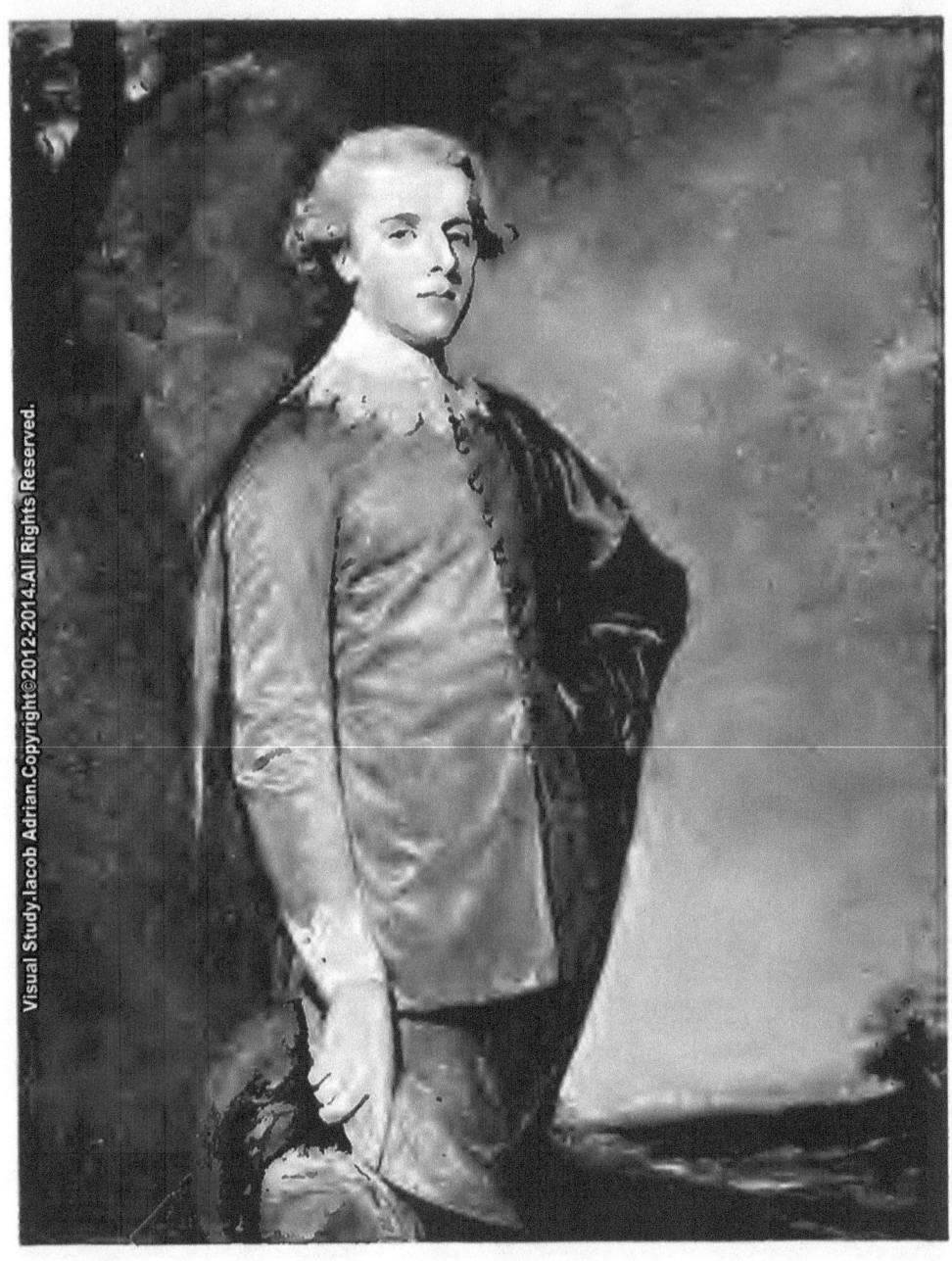

VISCOUNT TRENTHAM (1ST DUKE OF SUTHERLAND)
(*Duke of Sutherland, London*)
E. Harrison & Son, Photo.

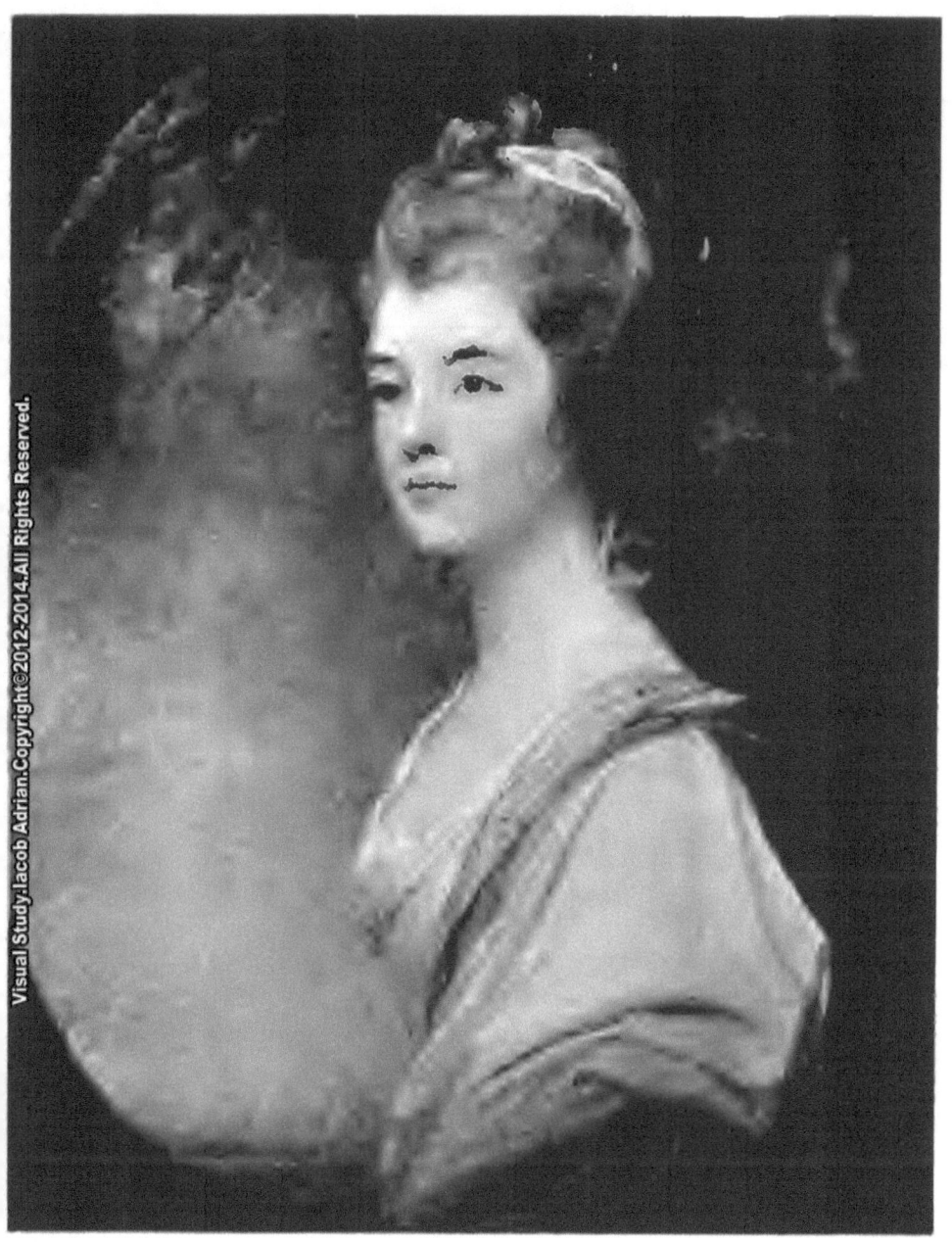

ELIZABETH, DUCHESS OF SUTHERLAND
(*Duke of Sutherland, London*)
E. Harrison & Son, Photo.

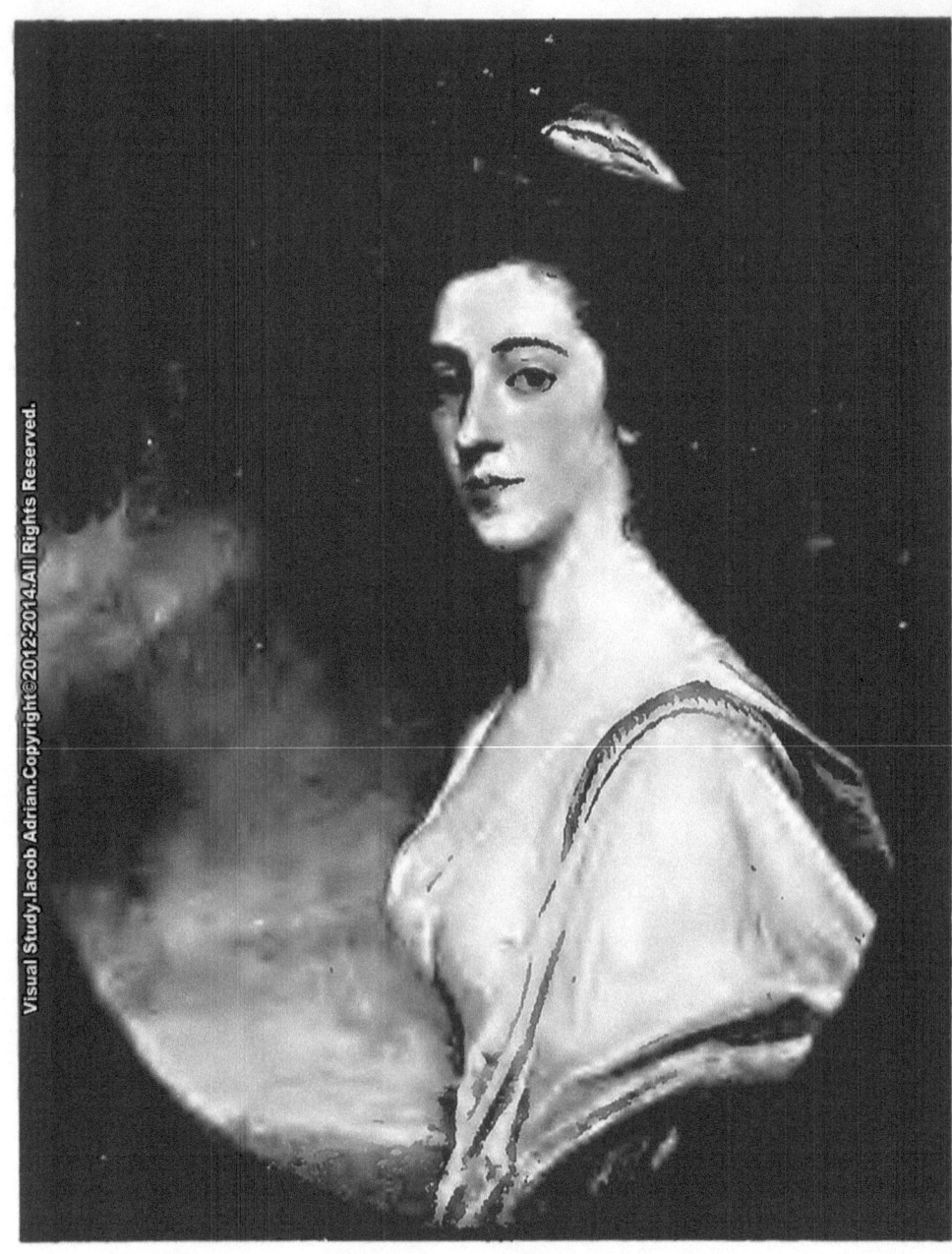

LOUISA, MARCHIONESS OF LANSDOWNE
(*Marquess of Lansdowne, London*)
Braun, Clément & Cie, Photo.

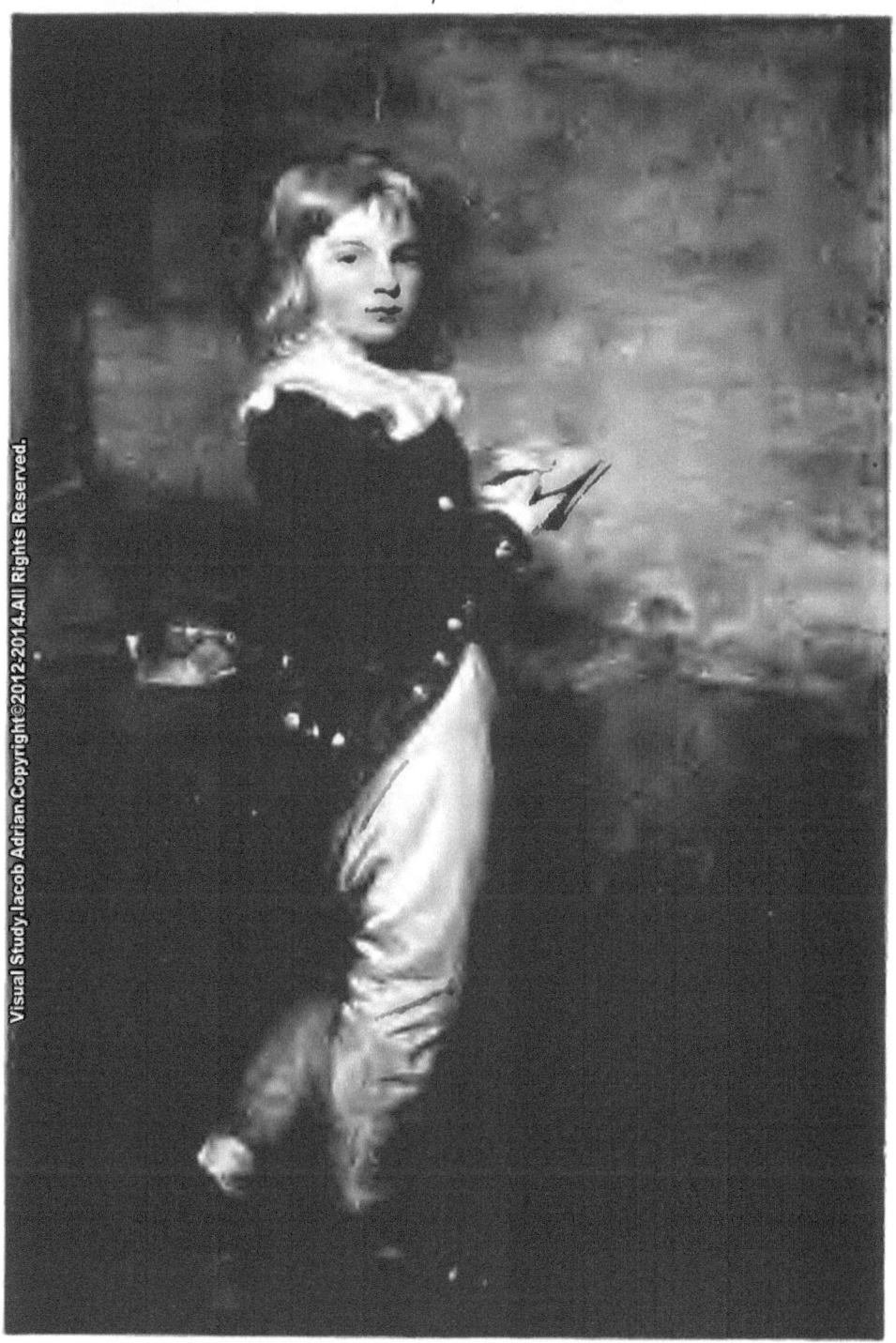

LORD HENRY PETTY
(Marquess of Lansdowne, London)
Braun, Clément & Cie, Photo.

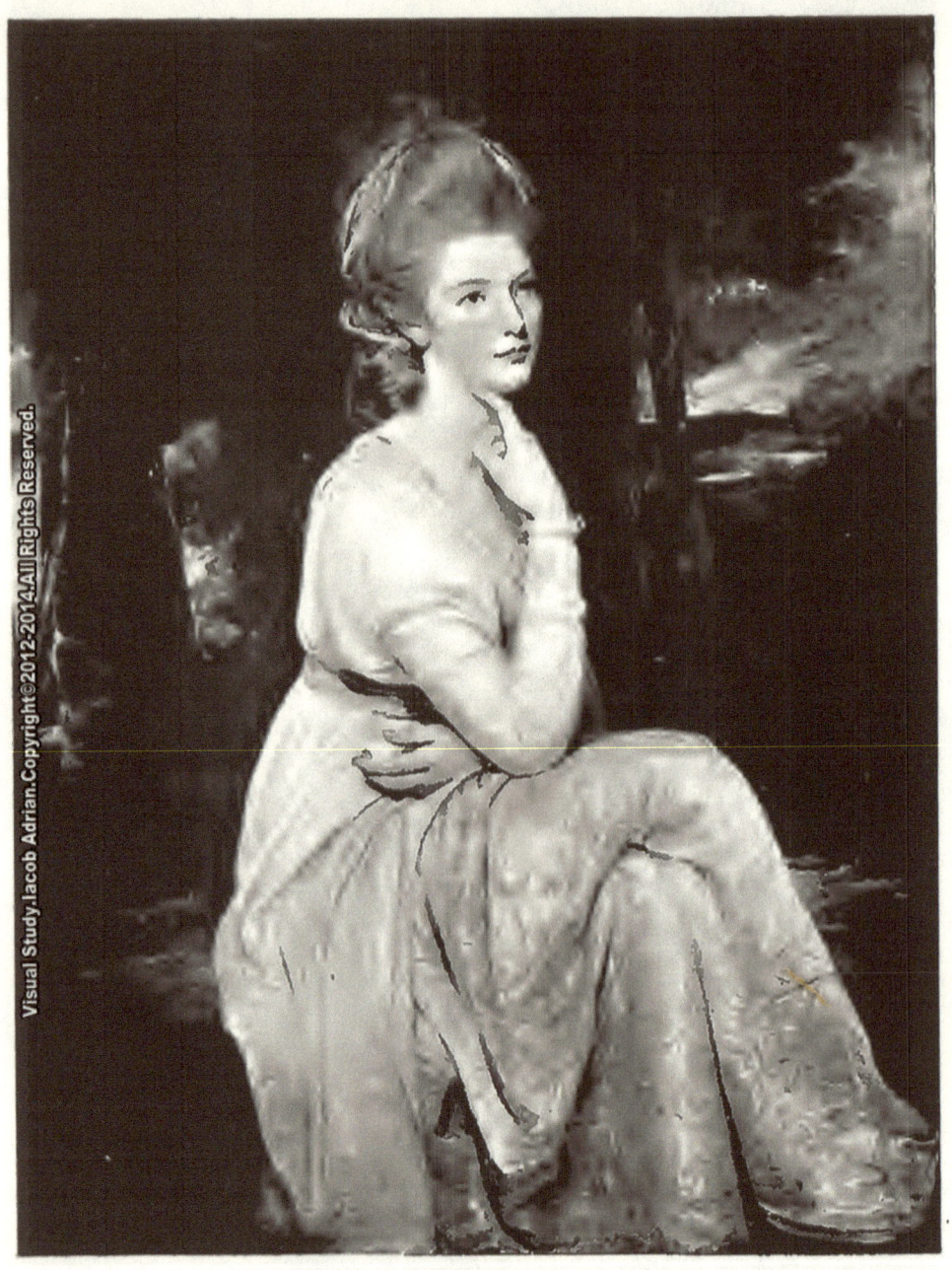

ELIZABETH, COUNTESS OF DERBY
(*Sir Edward Tennant, Bart., London*)
T. & R. Annan & Sons, Photo.

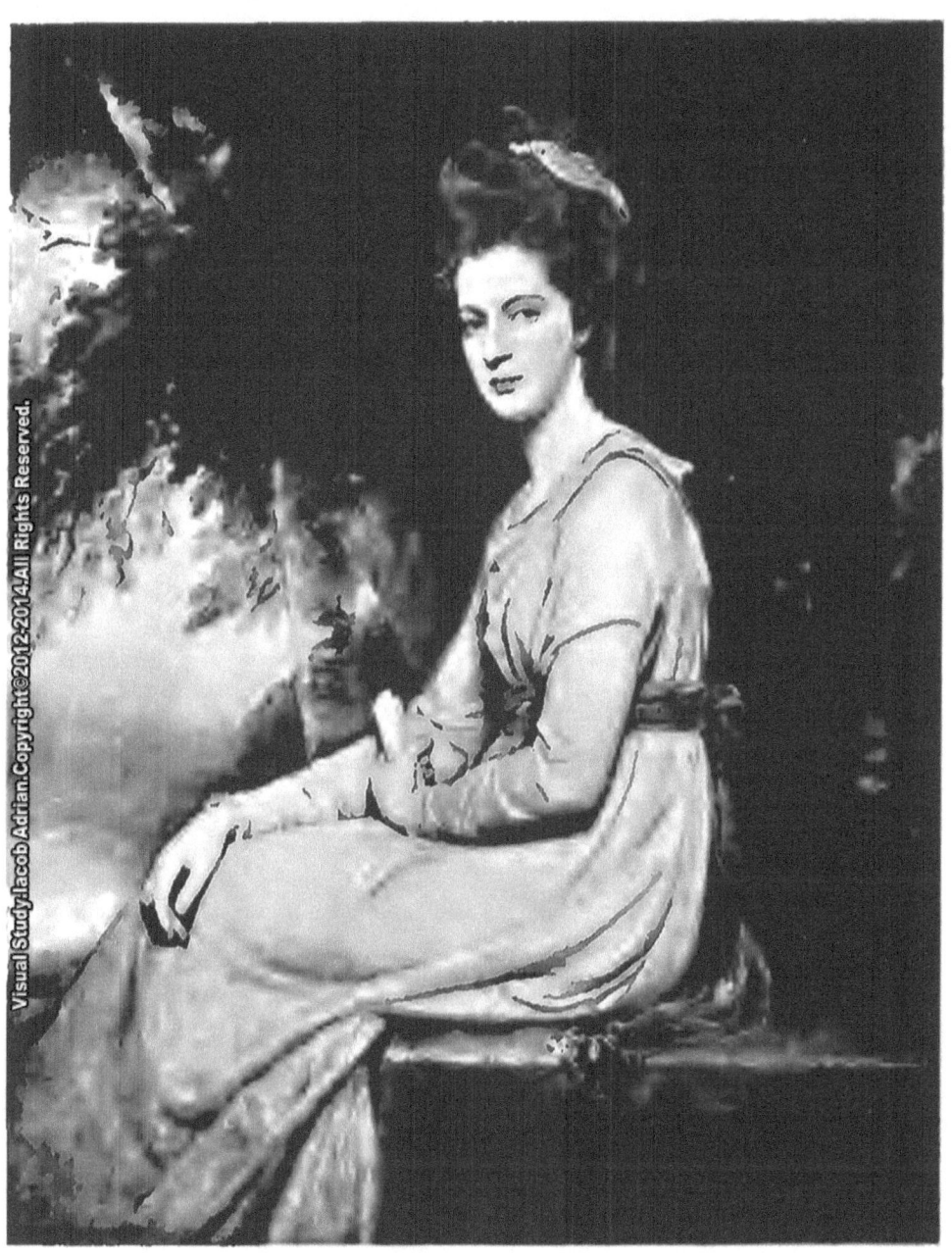

MARGARET, COUNTESS OF CARLISLE
(*Duke of Sutherland, London*)
E. Harrison & Son, Photo.

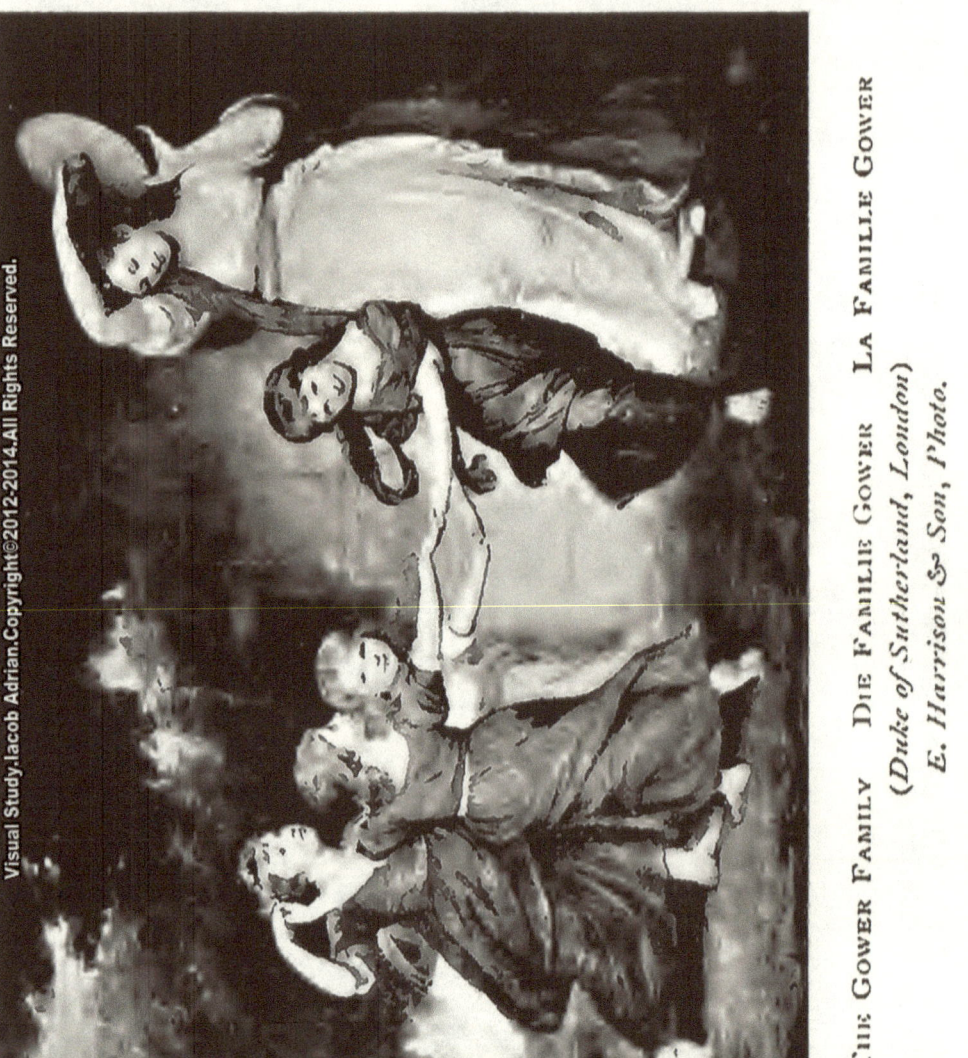

The Gower Family Die Familie Gower La Famille Gower
(Duke of Sutherland, London)
E. Harrison & Son, Photo.

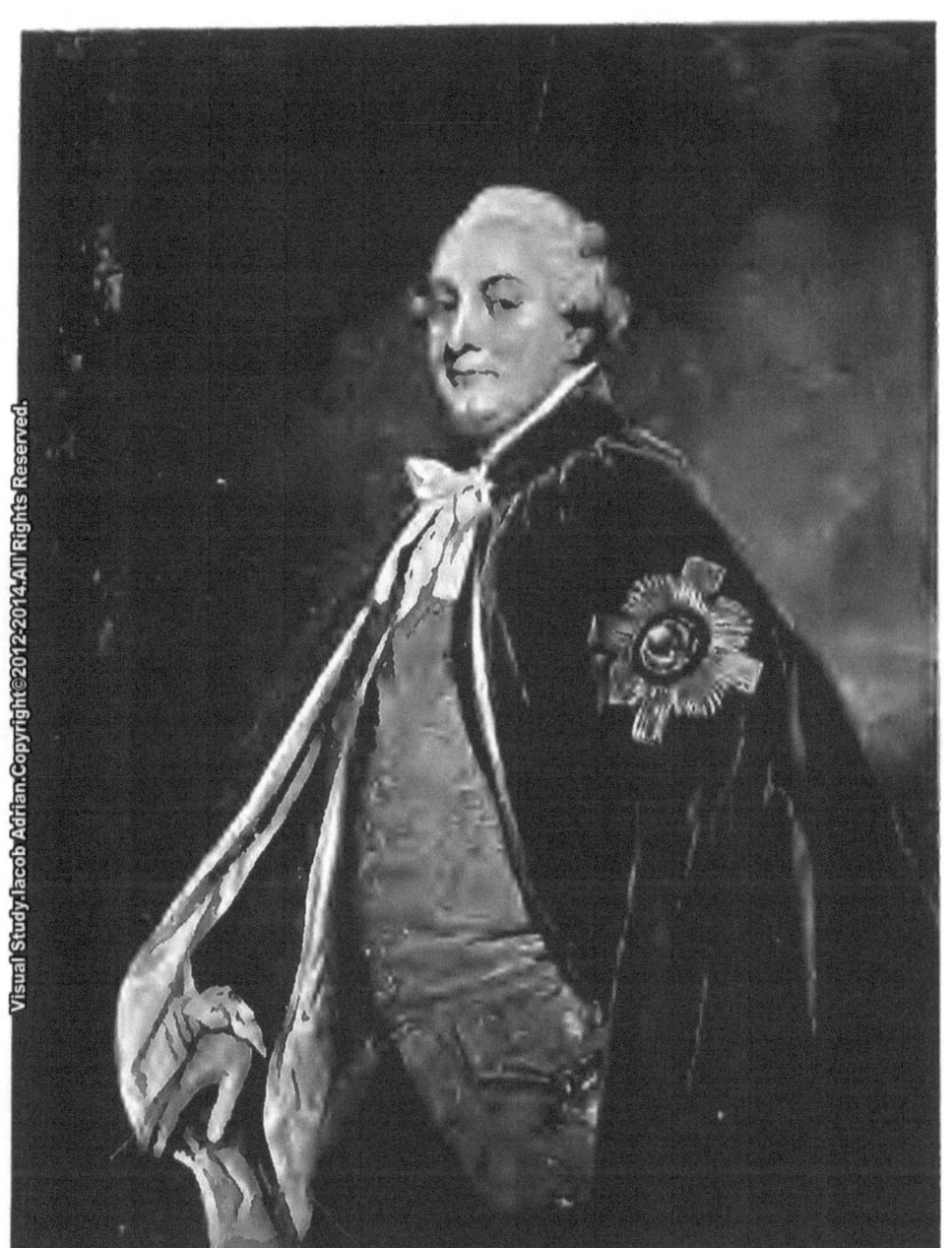

LORD STORMONT
(Christ Church College, Oxford)
W. A. Mansell & Co., Photo.

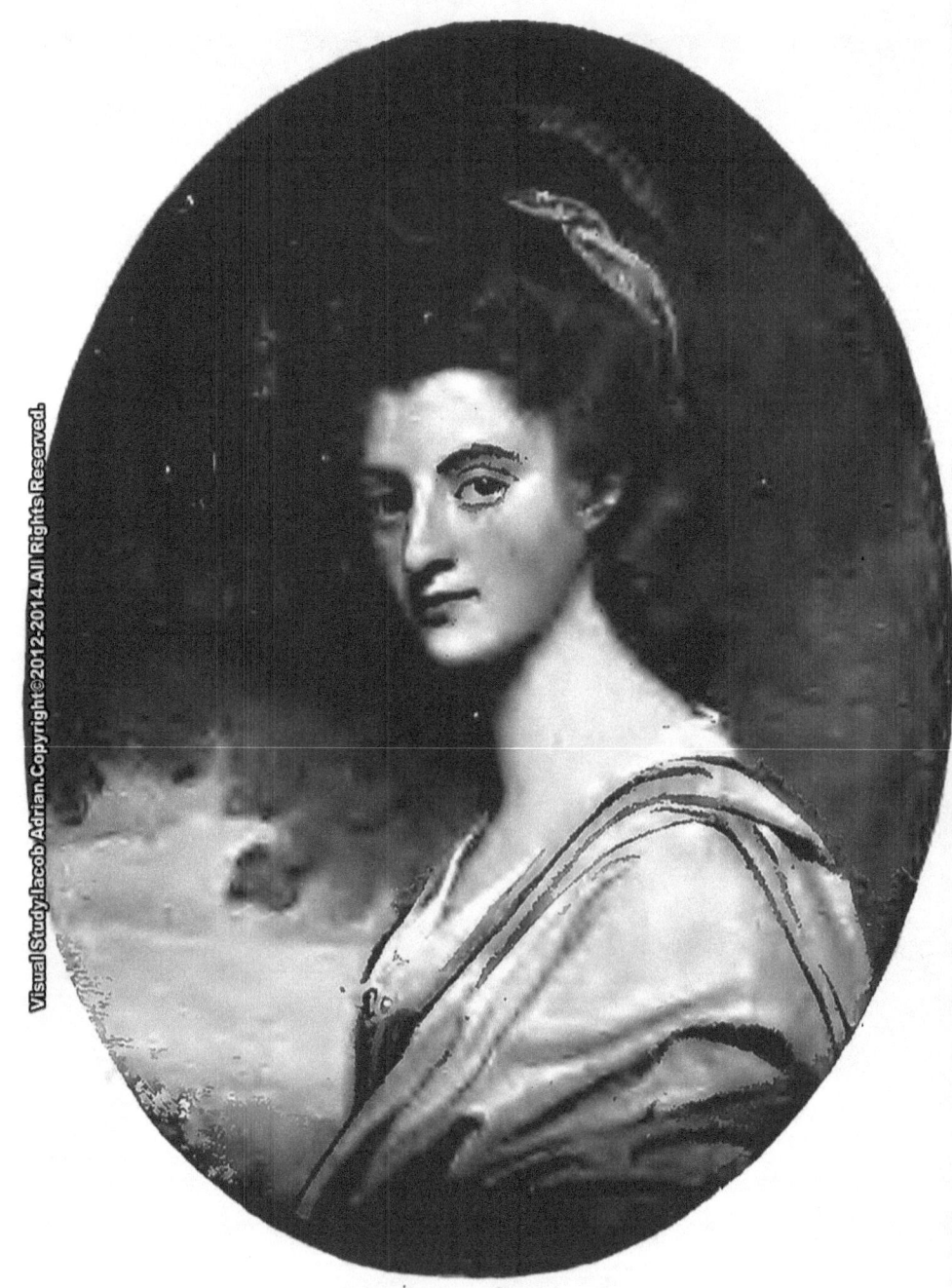

LADY CRAVEN
(*National Gallery, London*)
F. Hanfstaengl, Photo.

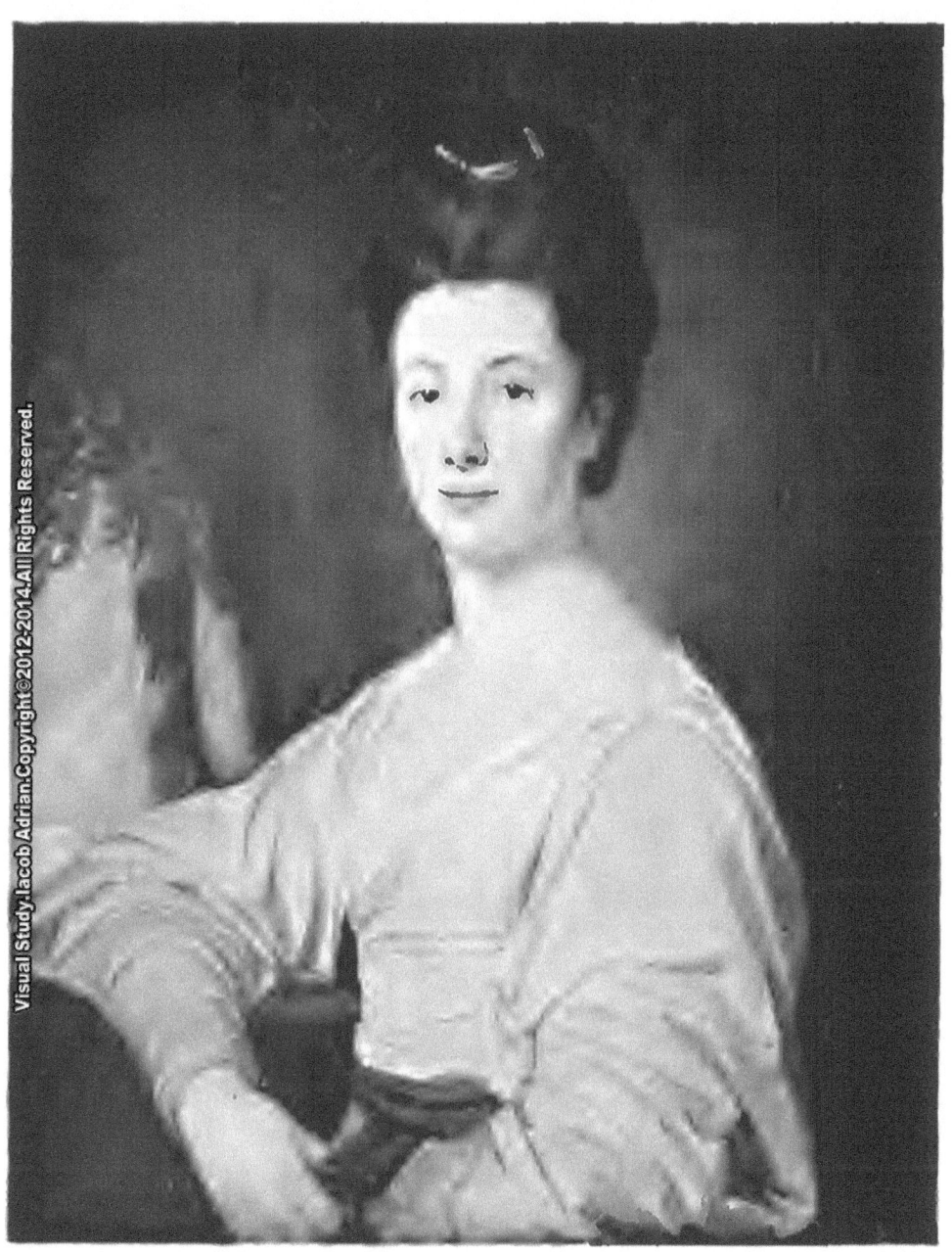

MRS. DE BURGH (LADY CLANRICARDE)
(*Mr. George Donaldson*)
F. Hanfstaengl, Photo.

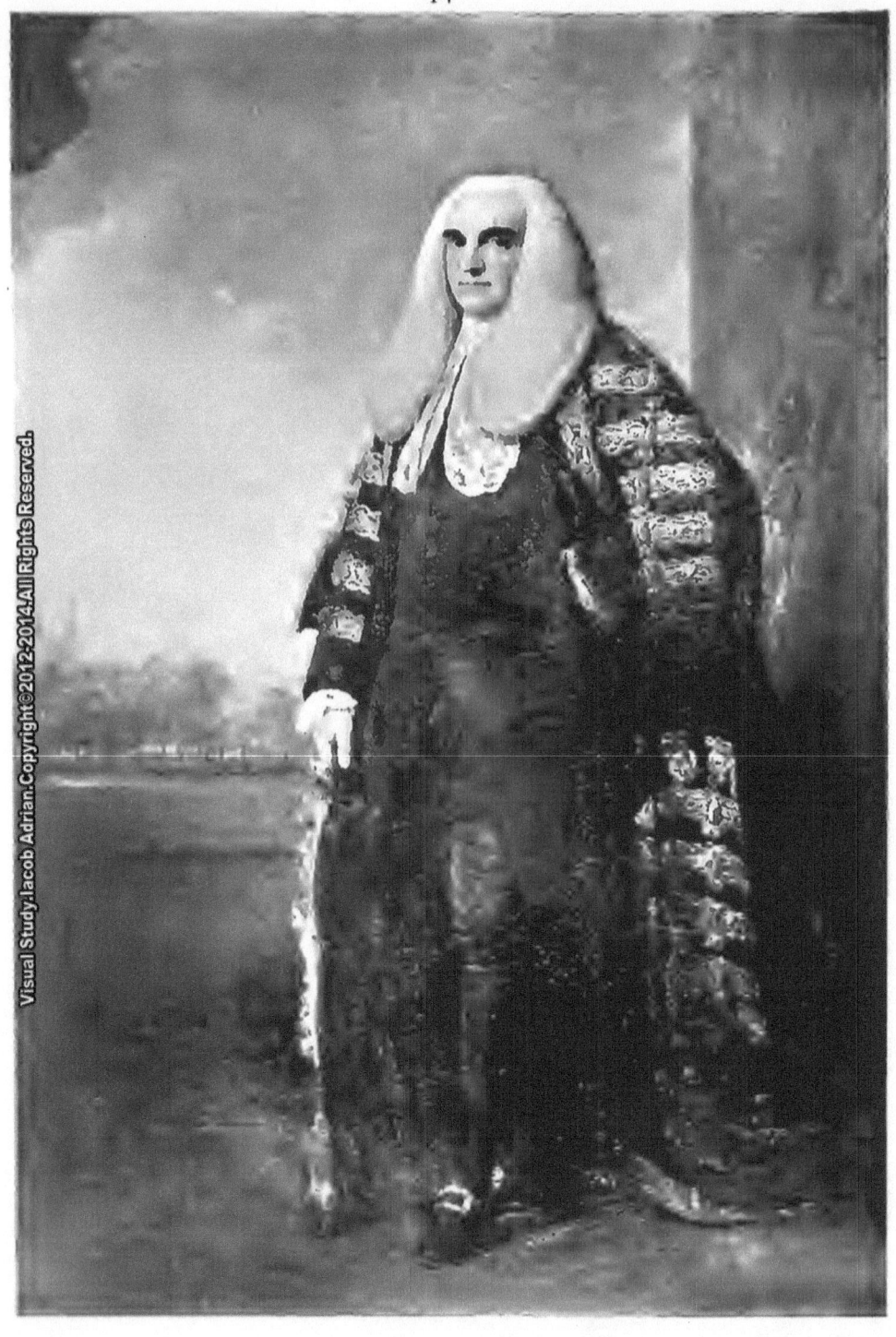

LORD THURLOW
(*Duke of Sutherland, London*)
E. Harrison & Son, Photo.

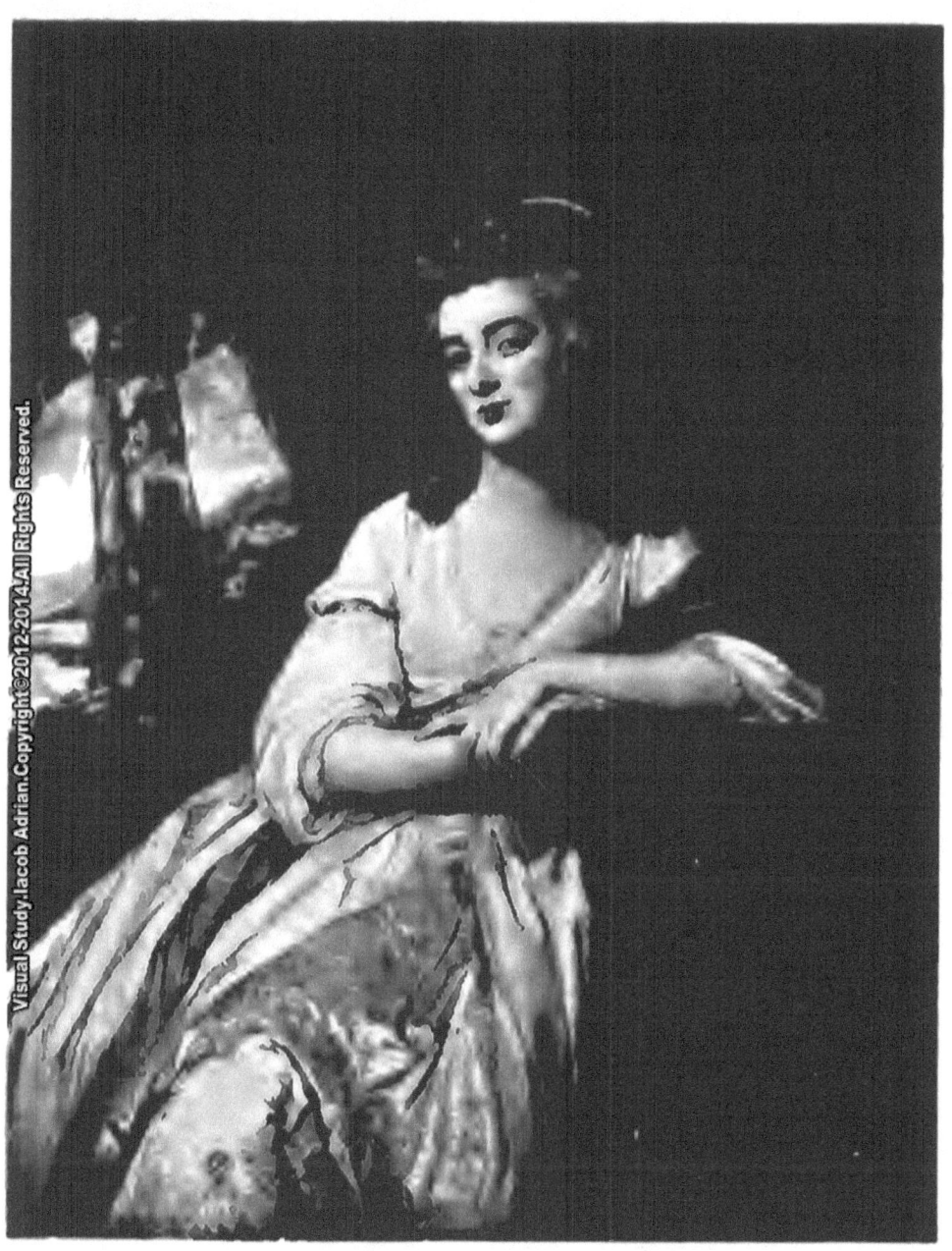

LADY PAULETT
(Mr. Alfred de Rothschild, London)
Braun, Clément & Cie, Photo.

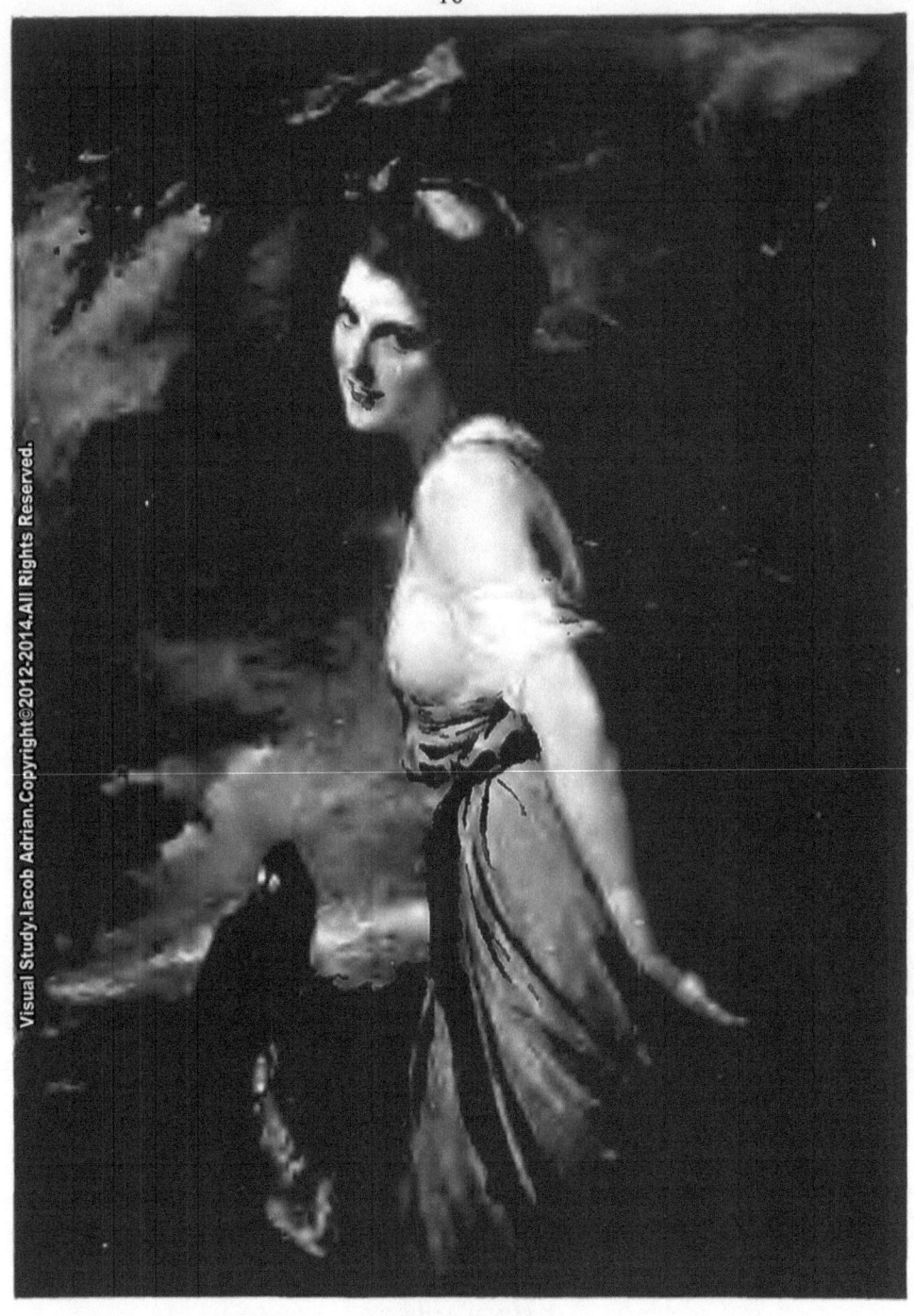

LADY HAMILTON
(*Mr. Tankeville Chamberlayne, Cranbury Park*)
Medici Socy. Ltd., Photo.

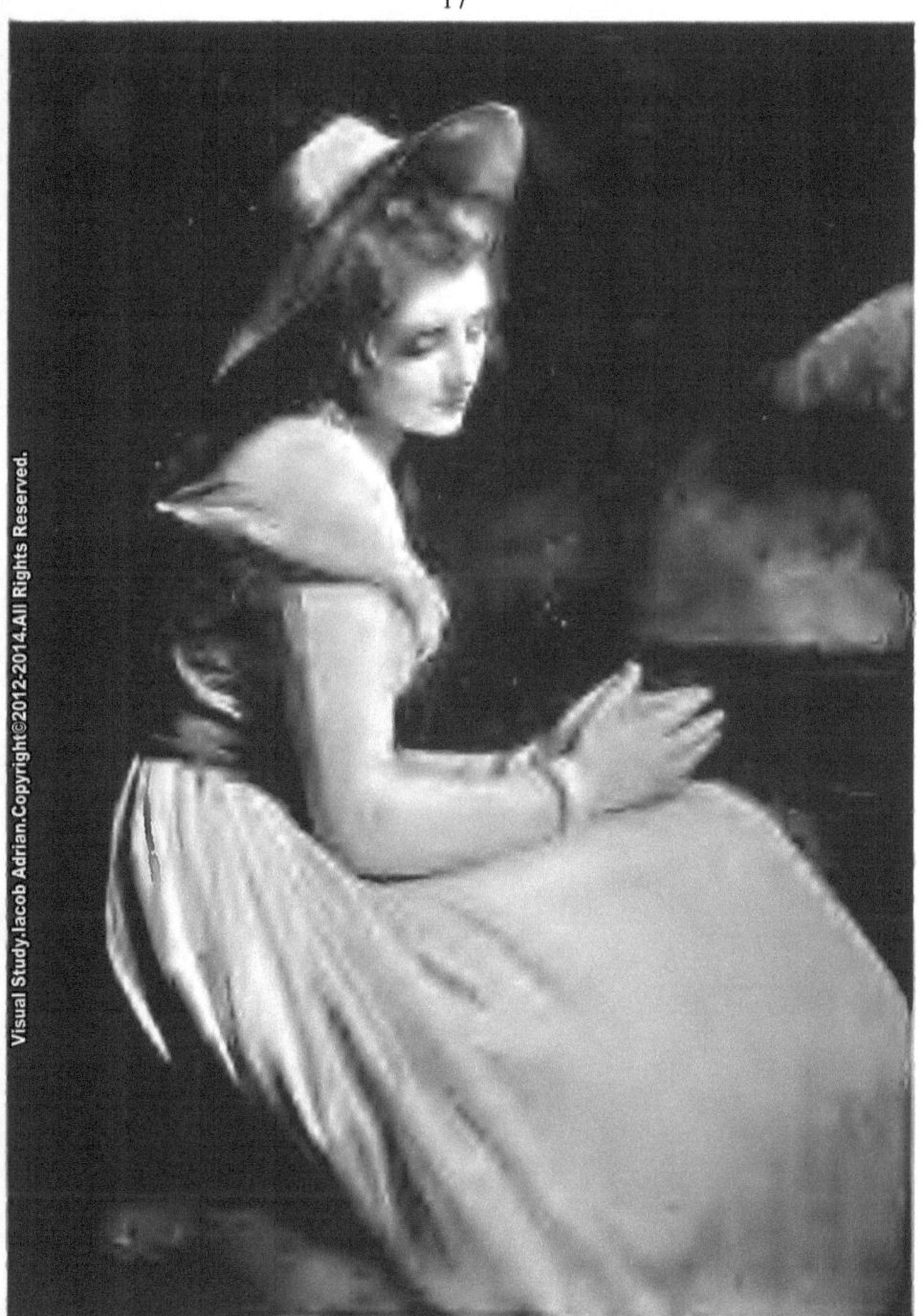

LADY HAMILTON
(*Sir Audley D. Neeld, Bart., Grittleton*)
Braun, Clément & Cie, Photo.

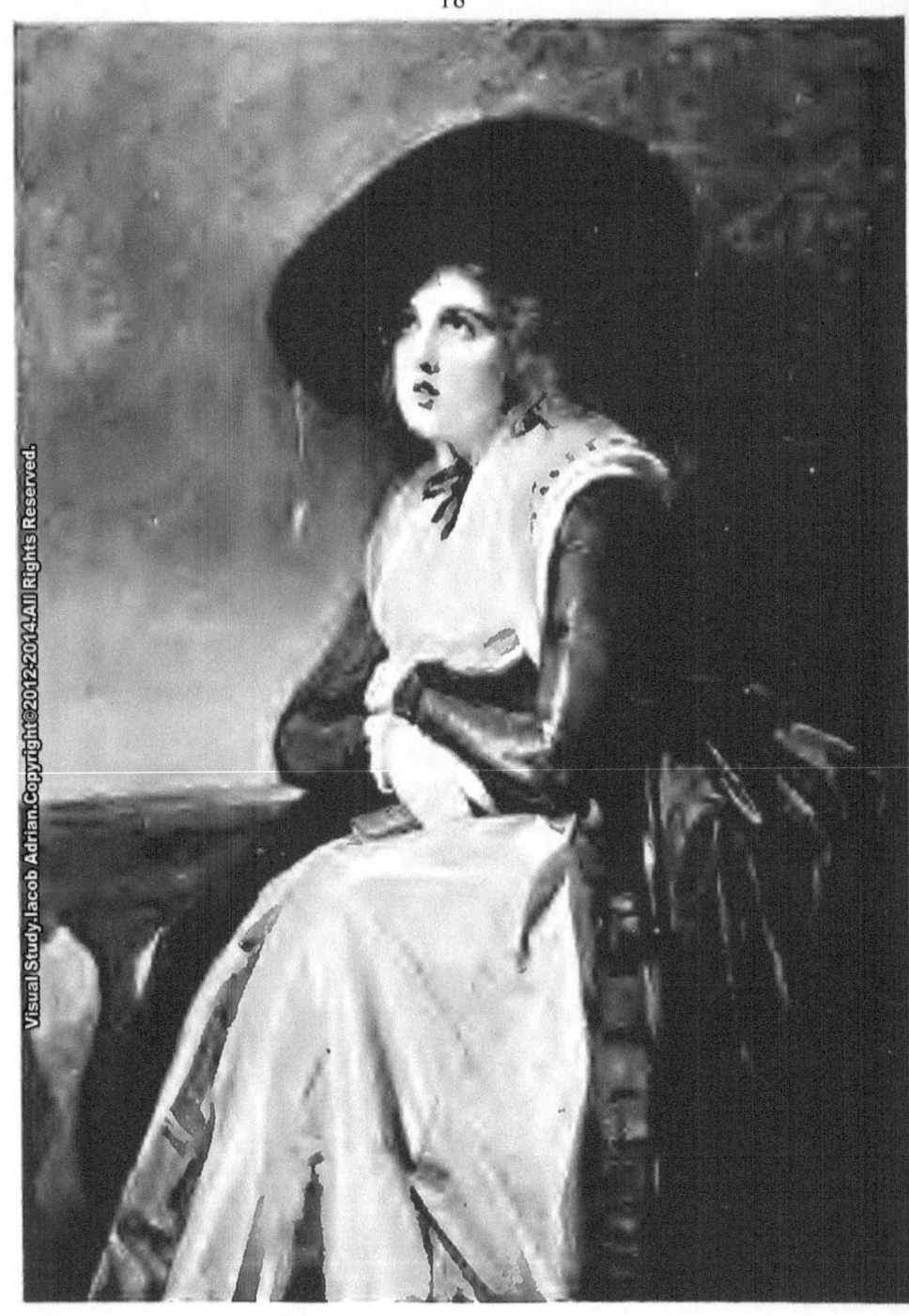

LADY HAMILTON
(*Mr. Alfred de Rothschild, London*)
Braun, Clément & Cie, Photo.

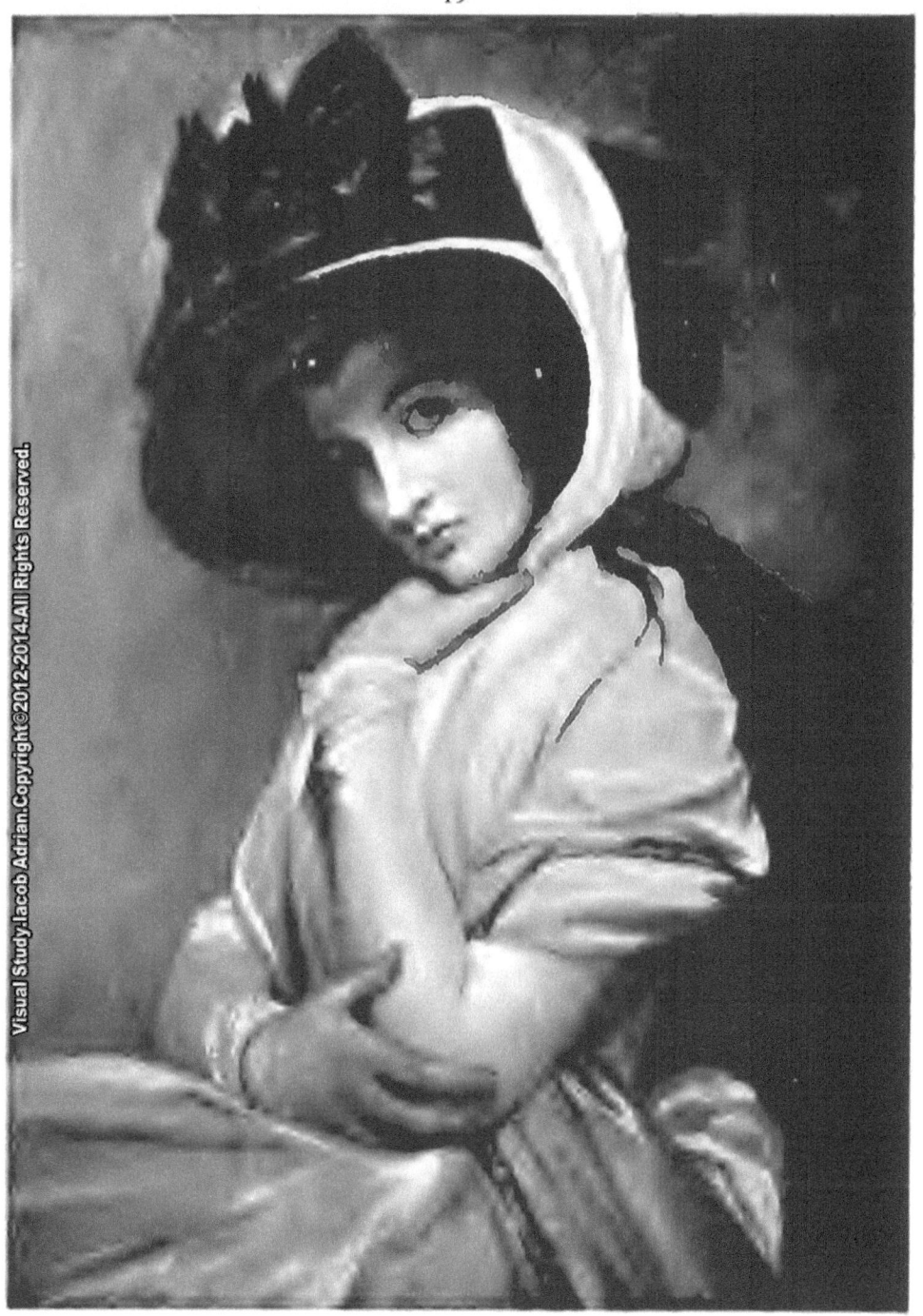

LADY HAMILTON
(*Mr. Alfred de Rothschild, London*)
Braun, Clément & Cie, Photo.

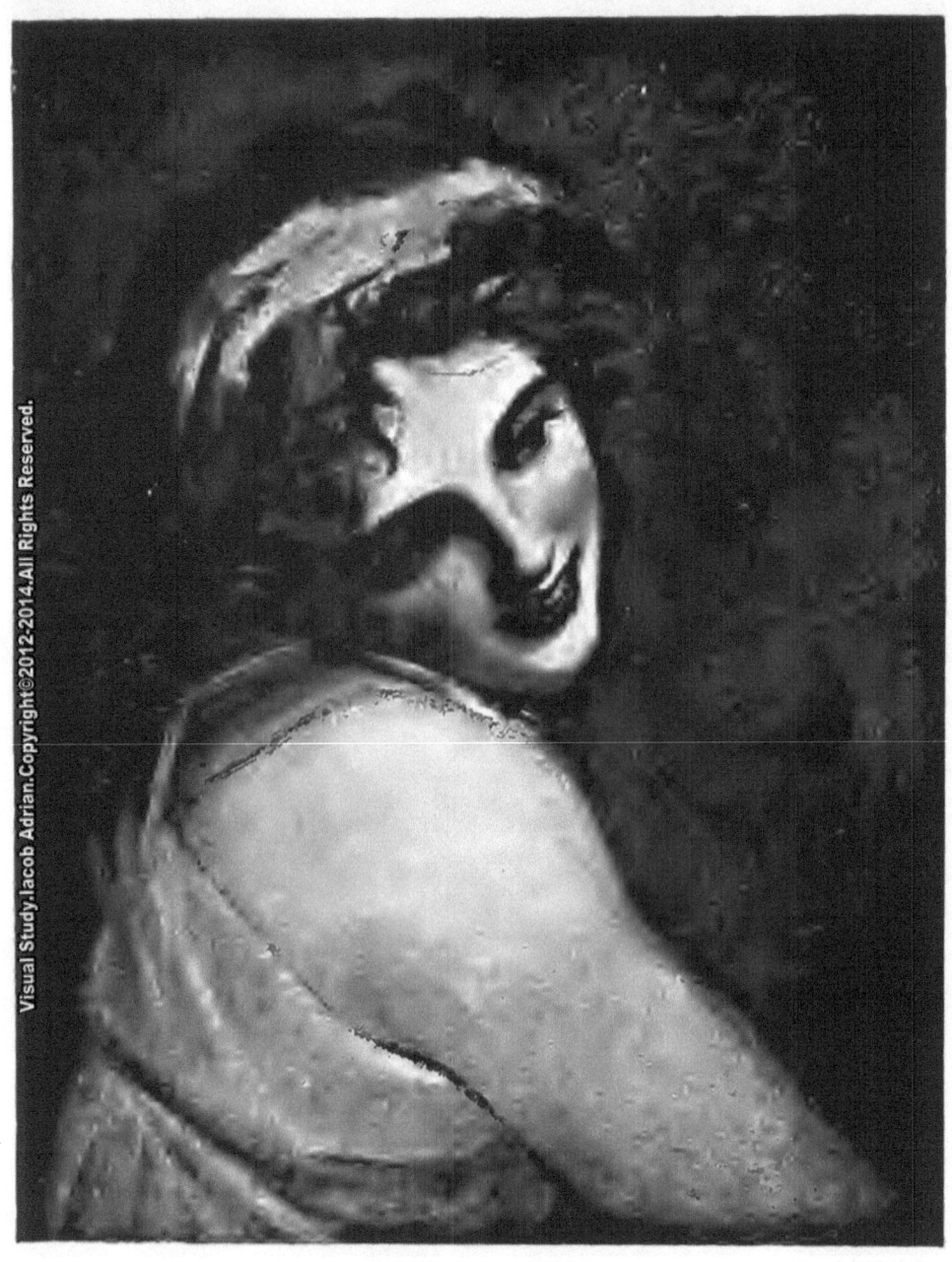

LADY HAMILTON
(*National Gallery, London*)
F. Hanfstaengl, Photo.

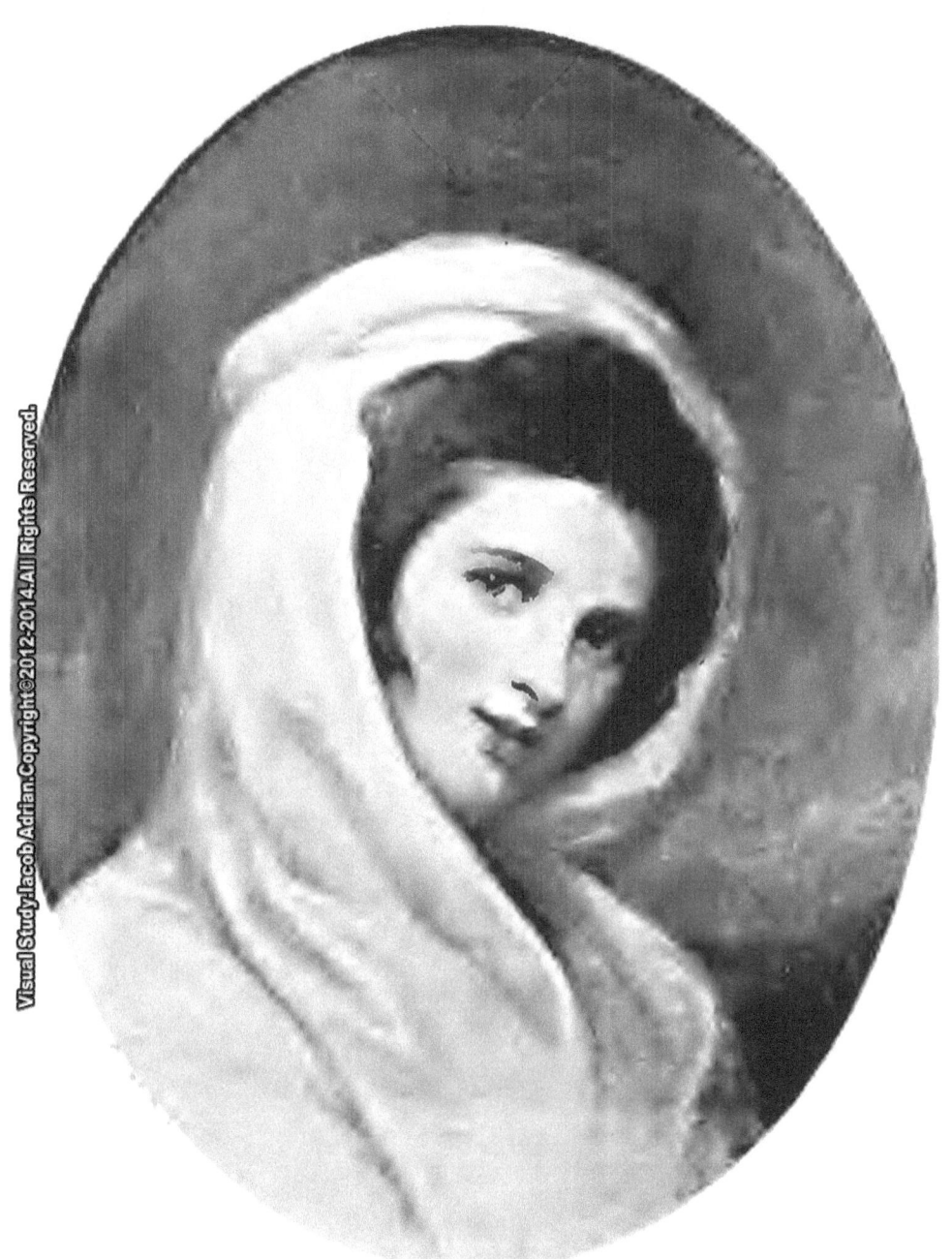

LADY HAMILTON
(*Sir Edward Tennant, Bart., London*)
W. A. Mansell & Co., Photo.

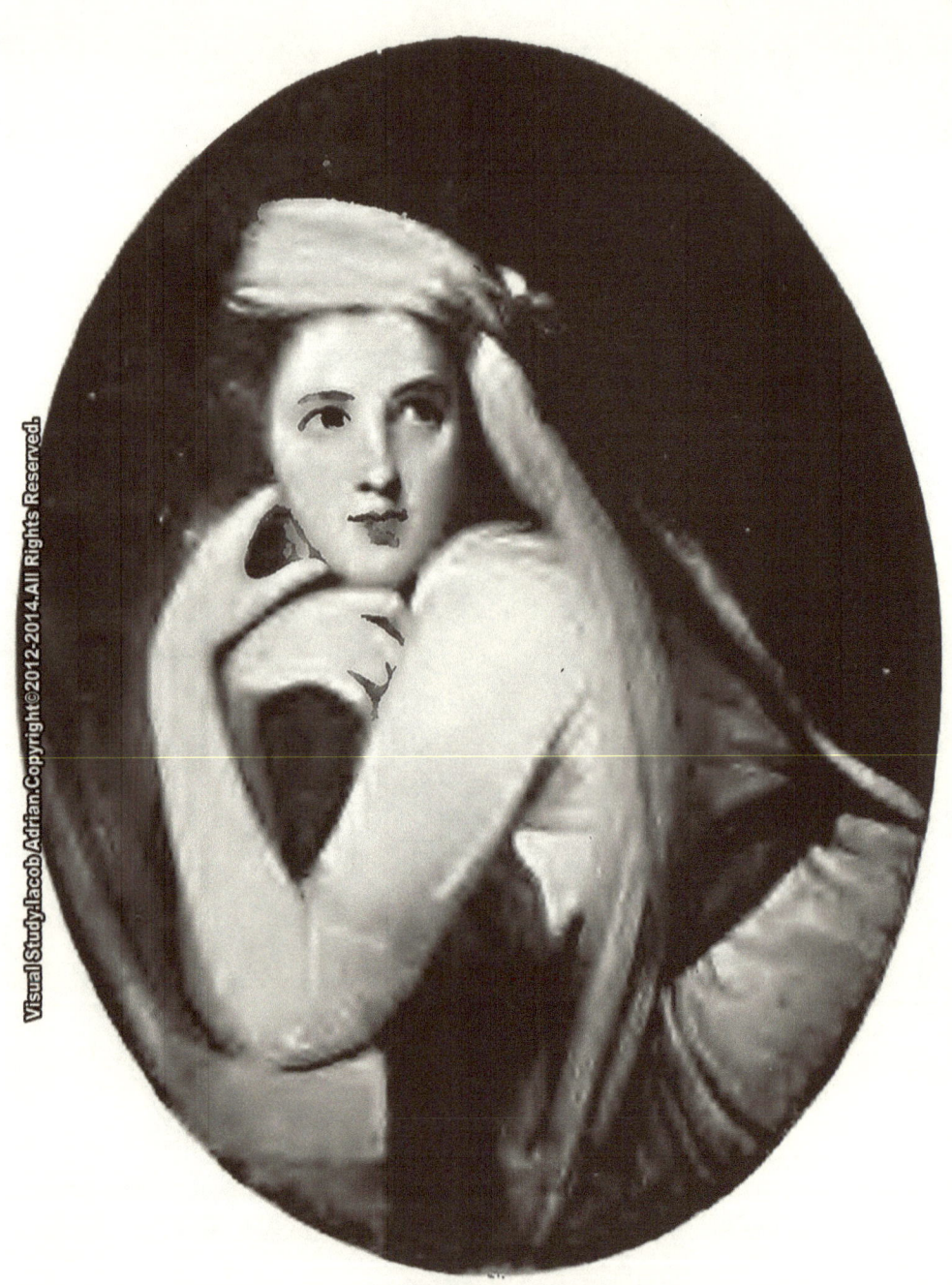

LADY HAMILTON
(*National Portrait Gallery, London*)
W. A. Mansell & Co., Photo.

LADY HAMILTON
(*National Gallery, London*)
F. Hanfstaengl, Photo.

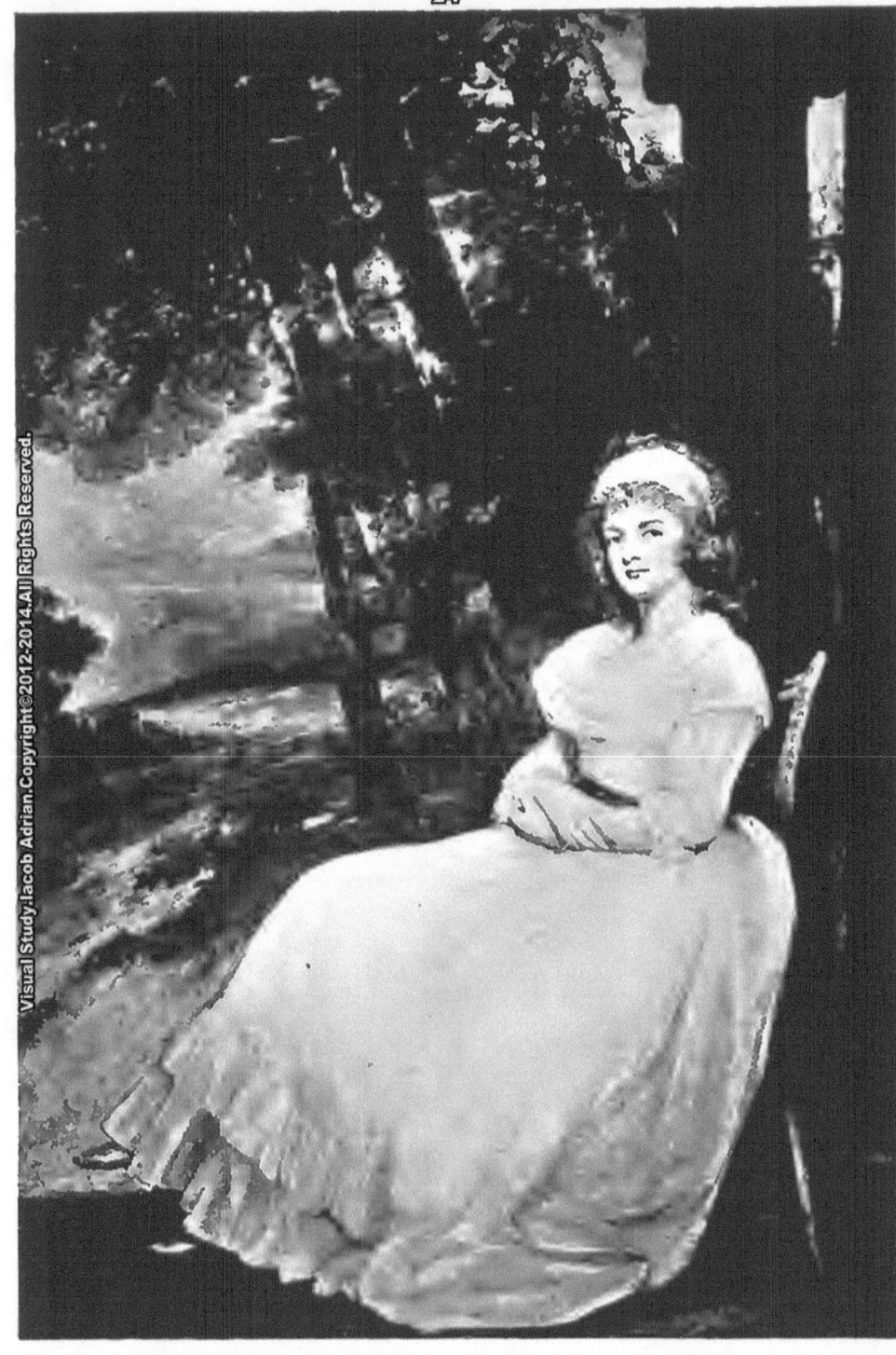

LADY MILNER
(*Lord Curzon, London*)

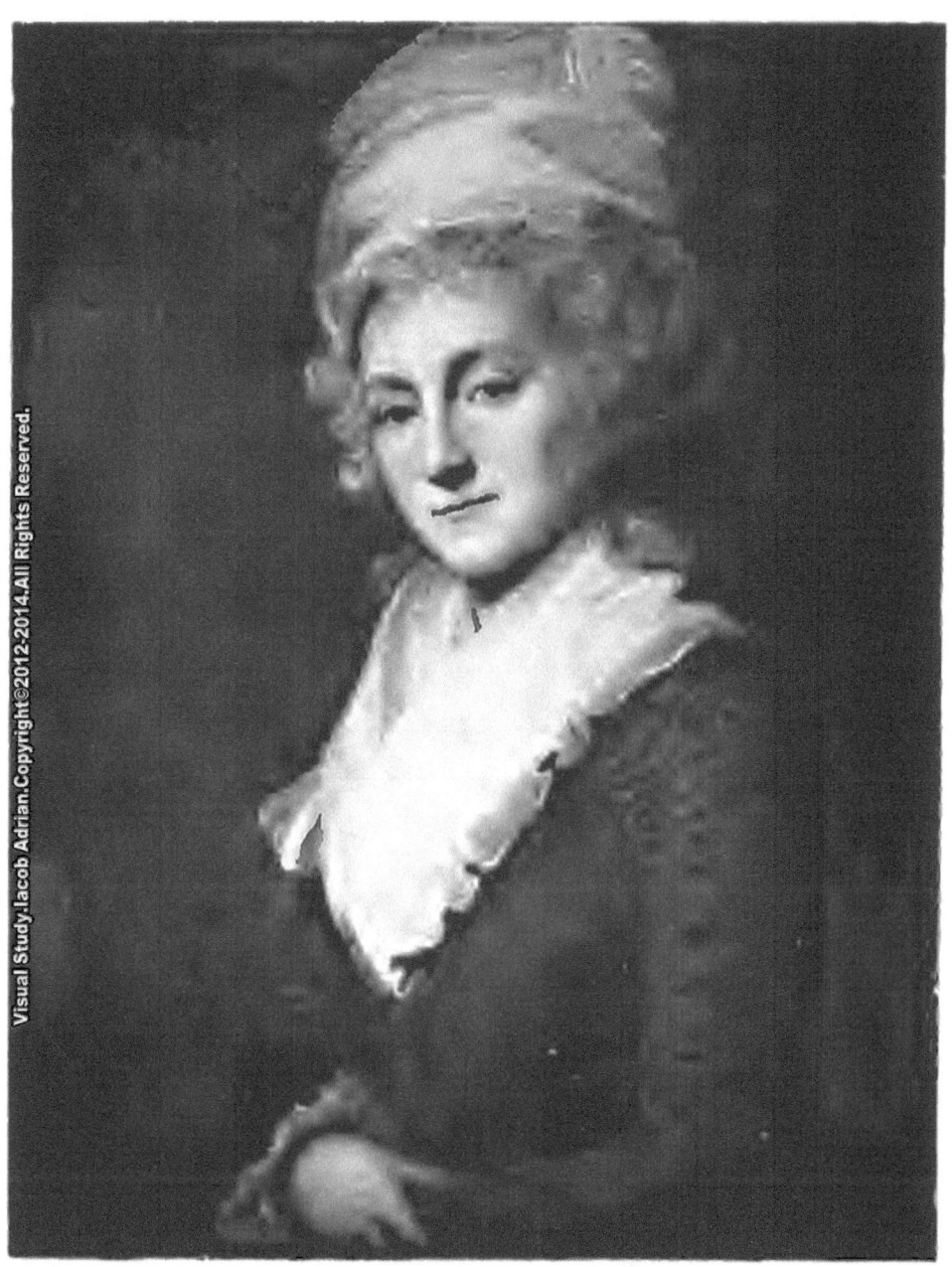

LADY HOLTE
(Corporation Gallery, Birmingham)
F. Hanfstaengl, Photo.

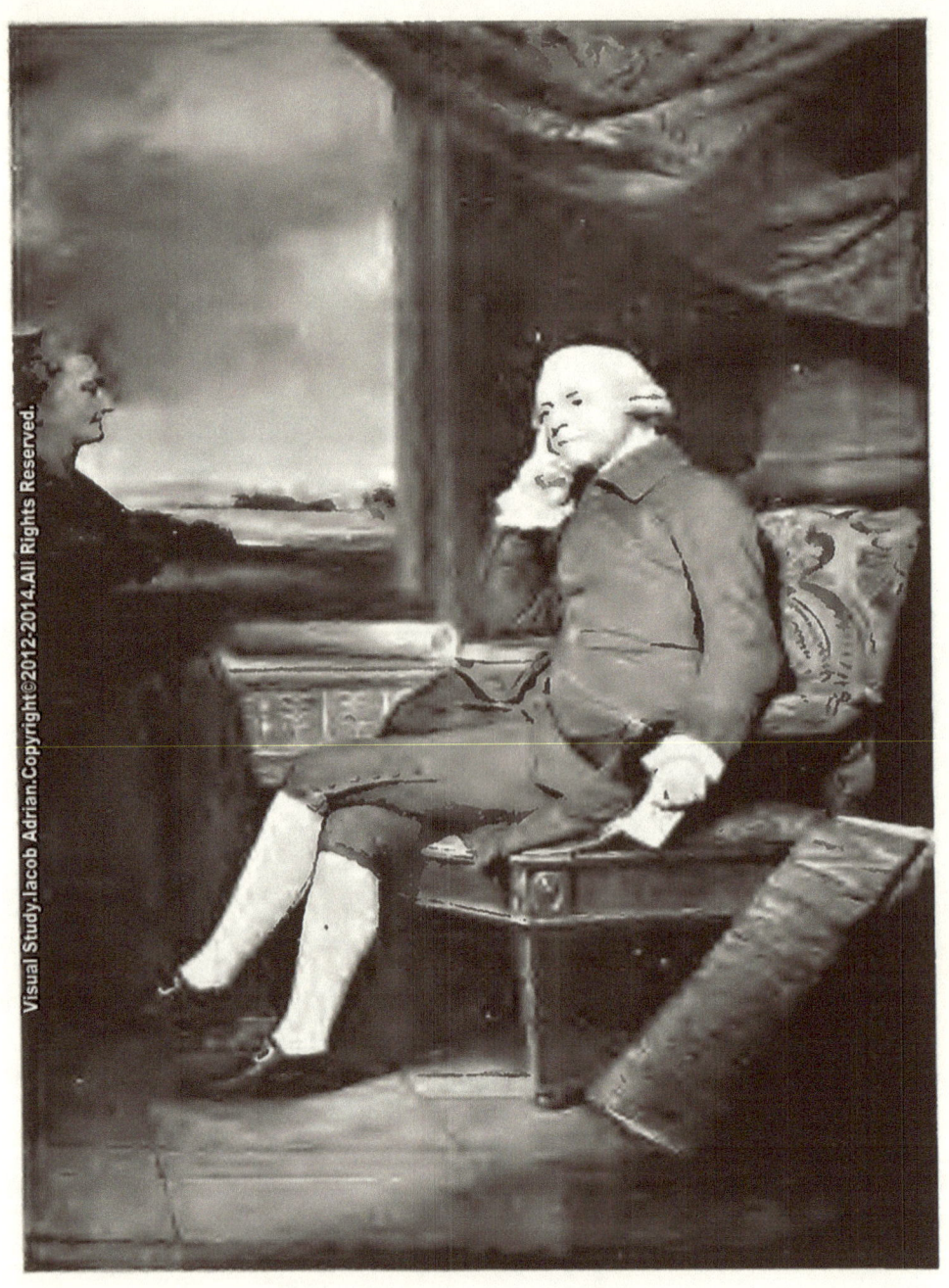

SIR JOHN STANLEY
(*Louvre, Paris*)
W. A. Mansell & Co., Photo.

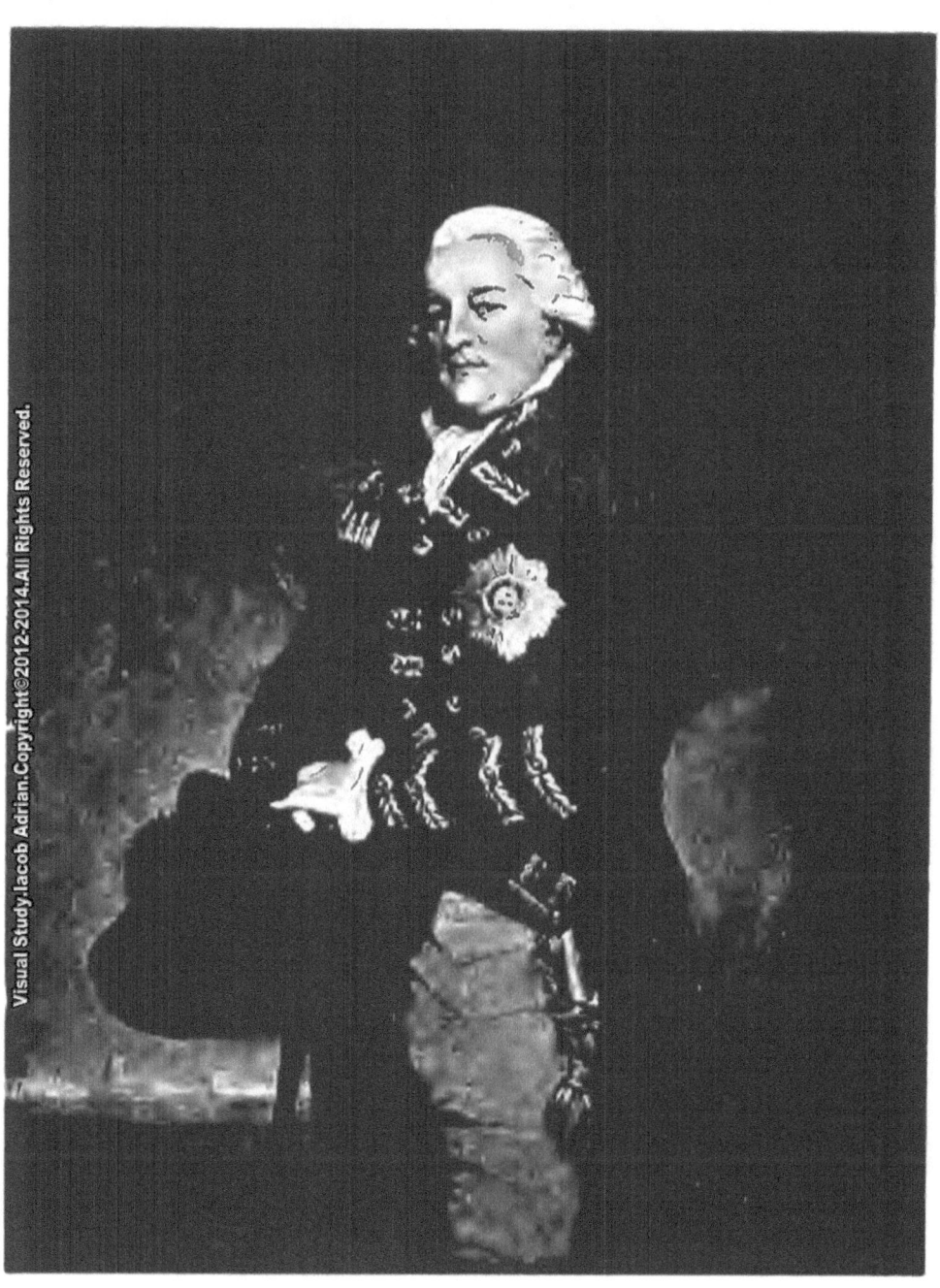

SIR ARCHIBALD CAMPBELL.
(*M. Charles Sedelmeyer, Paris*)

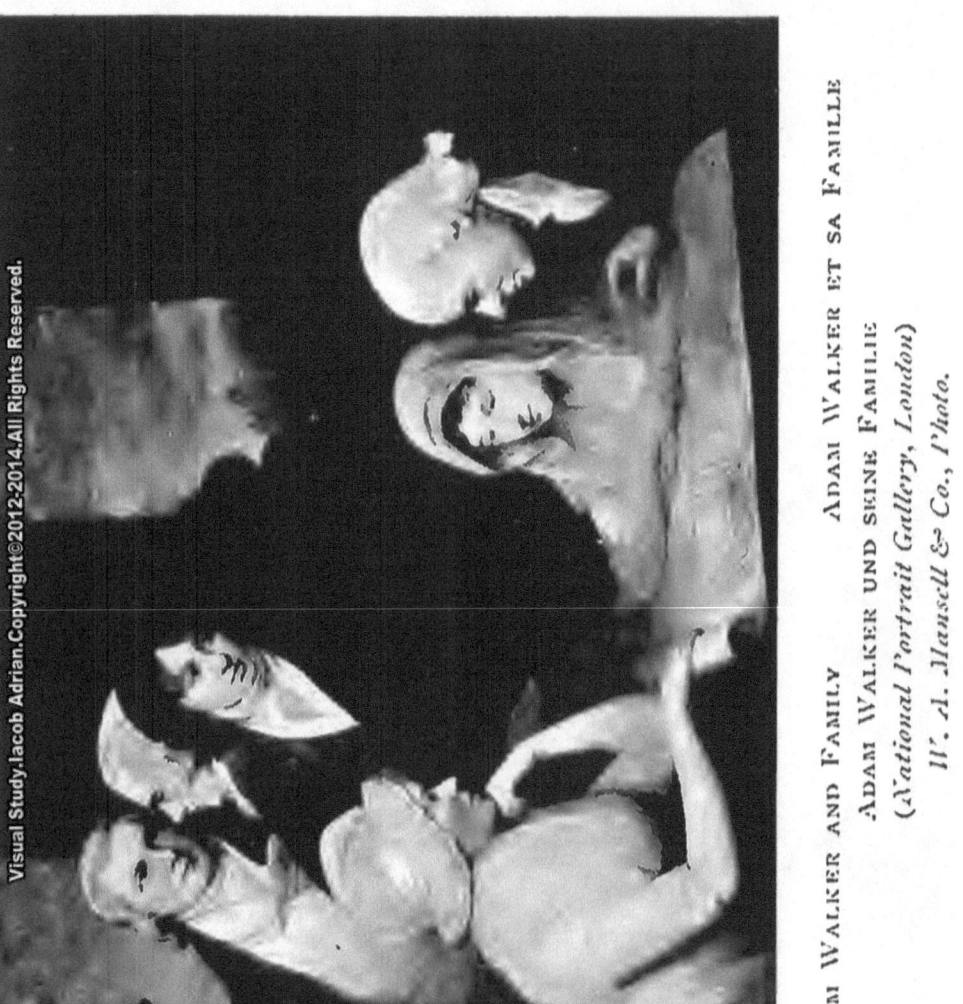

ADAM WALKER AND FAMILY ADAM WALKER ET SA FAMILLE
ADAM WALKER UND SEINE FAMILIE
(*National Portrait Gallery, London*)
W. A. Mansell & Co., Photo.

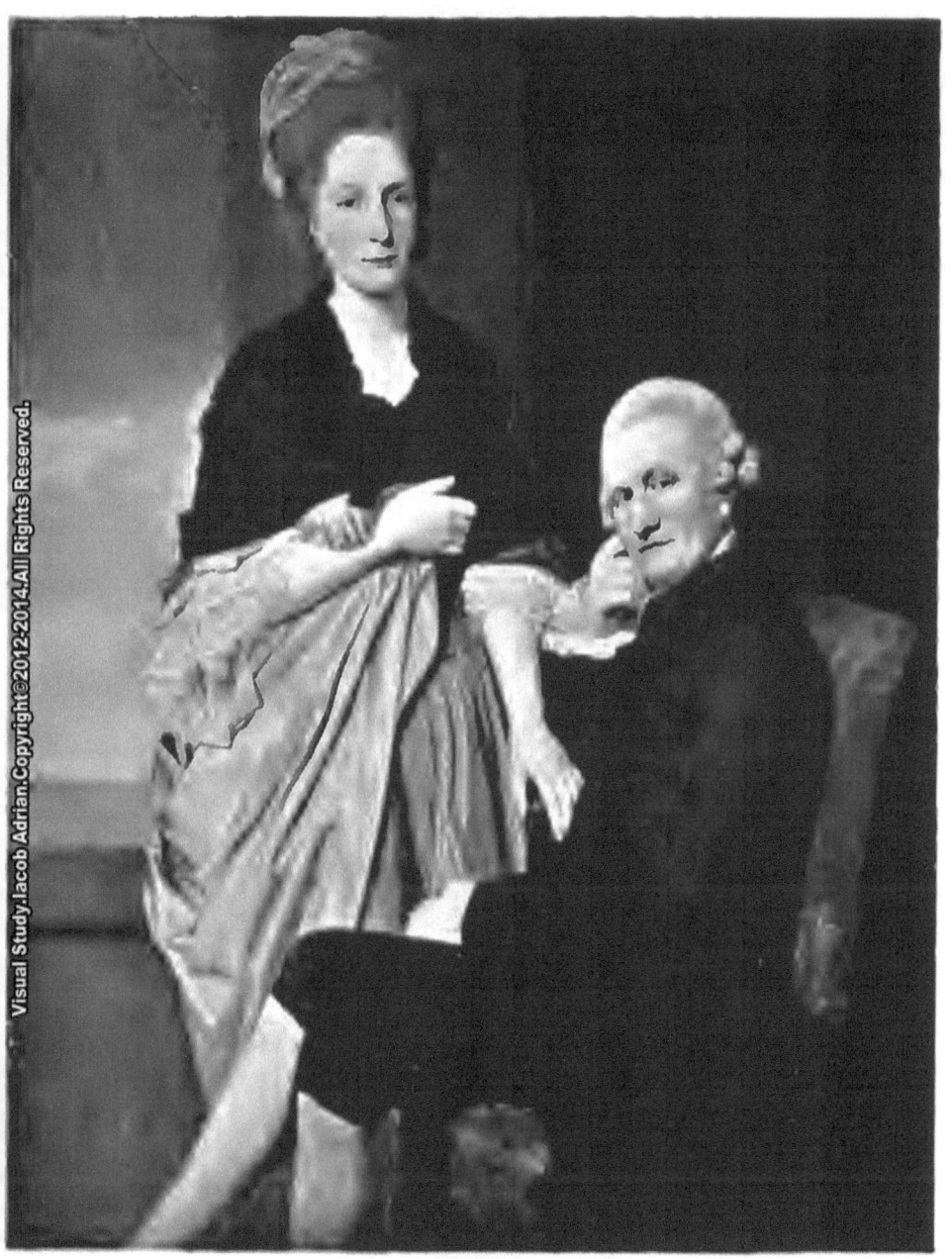

MR. & MRS. LINDOW
(*National Gallery, London*)
F. Hanfstaengl, Photo.

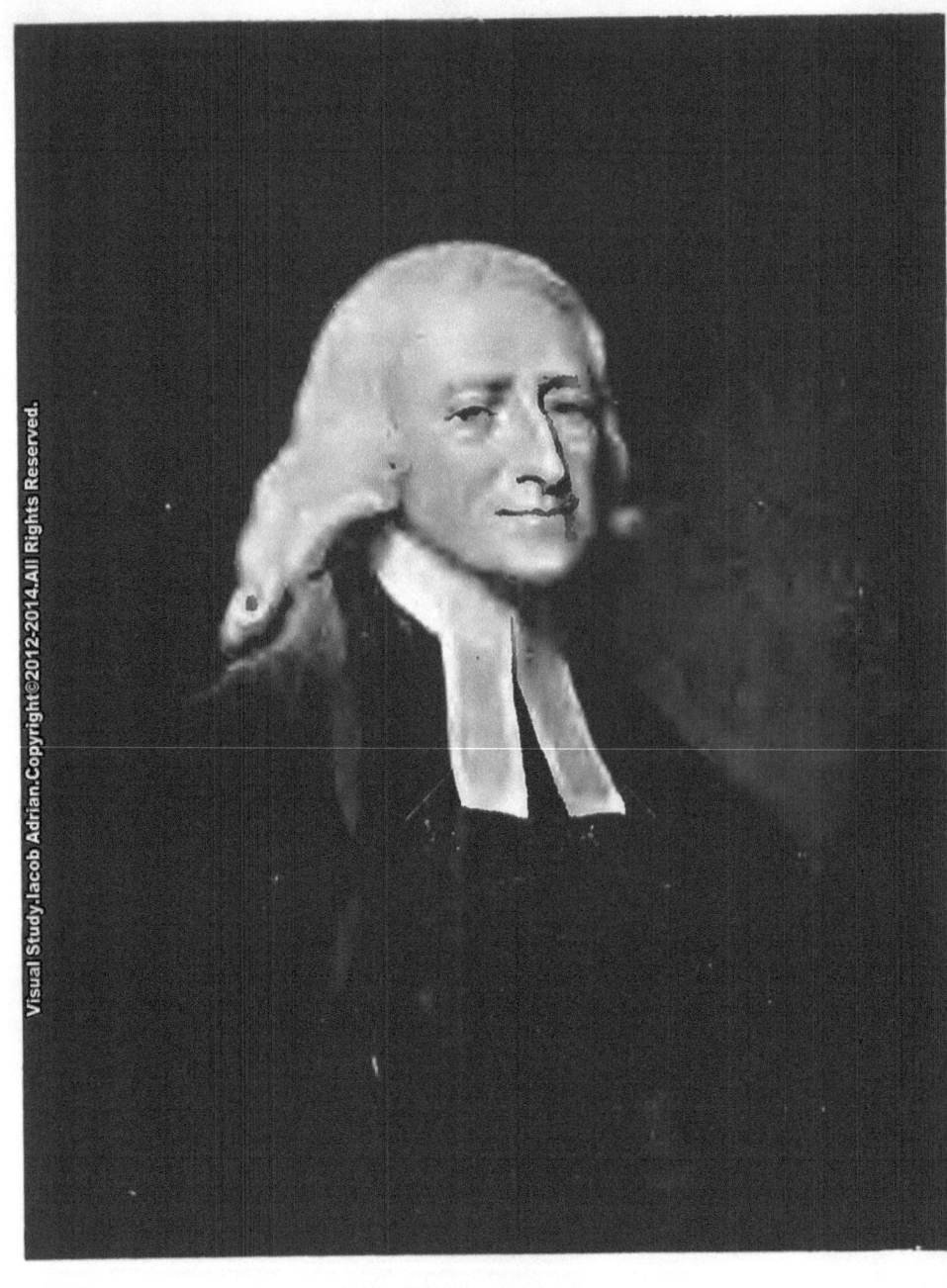

JOHN WESLEY
(Christ Church College, Oxford)
W. A. Mansell & Co., Photo.

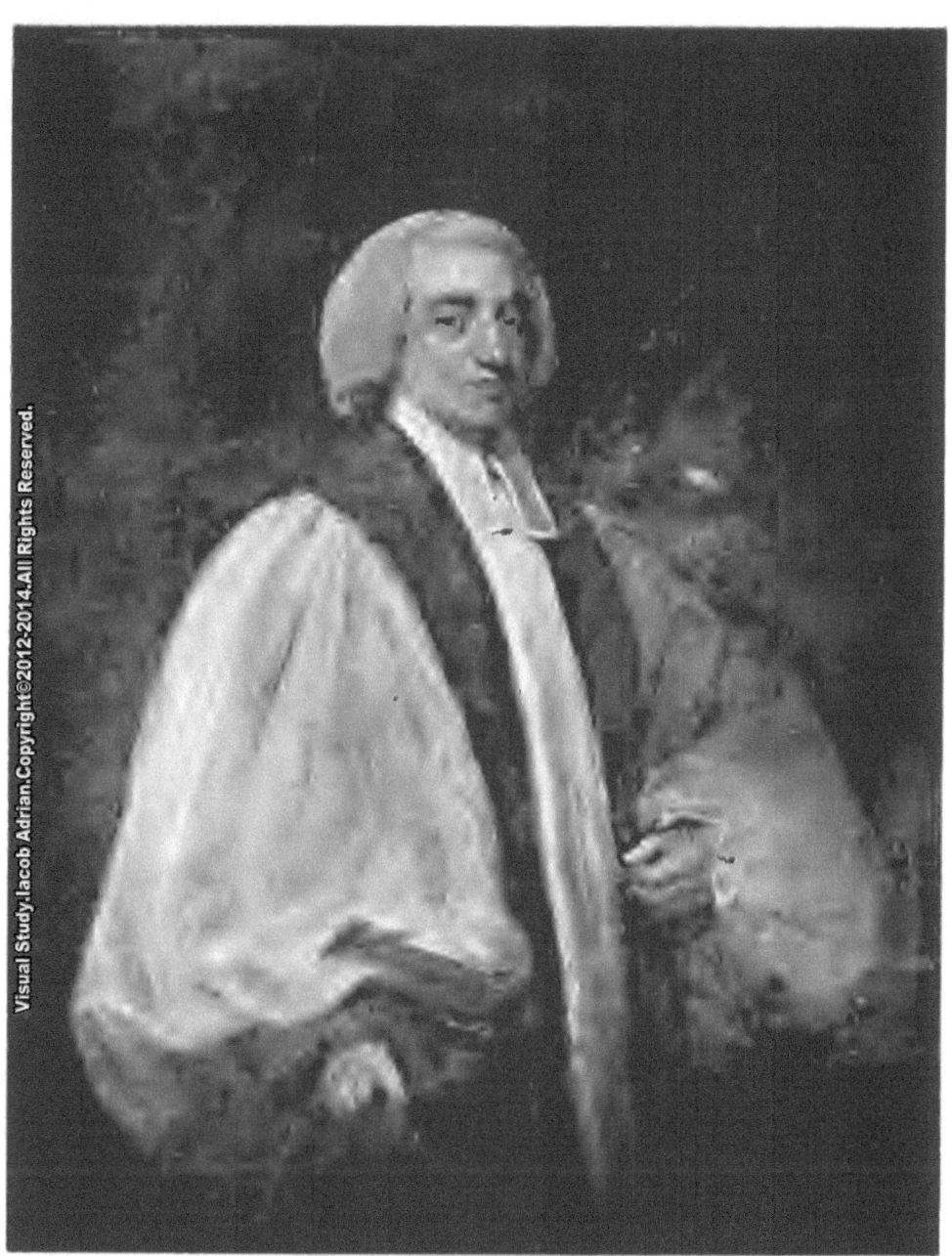

Rev. Charles Agar
(Christ Church College, Oxford)
W. A. Mansell & Co., Photo.

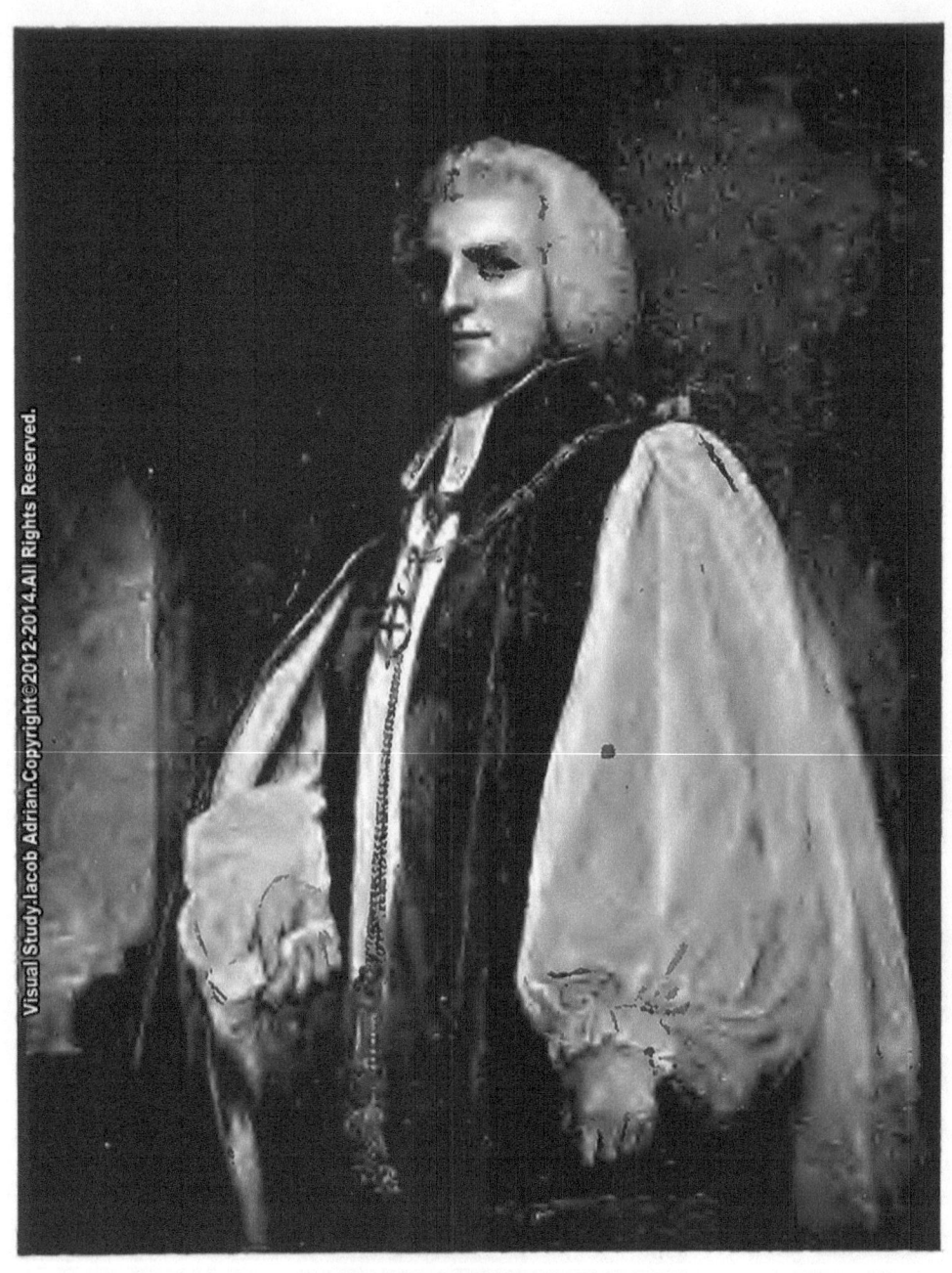

SHUTE BARRINGTON
(*Christ Church College, Oxford*)
W. A. Mansell & Co., Photo.

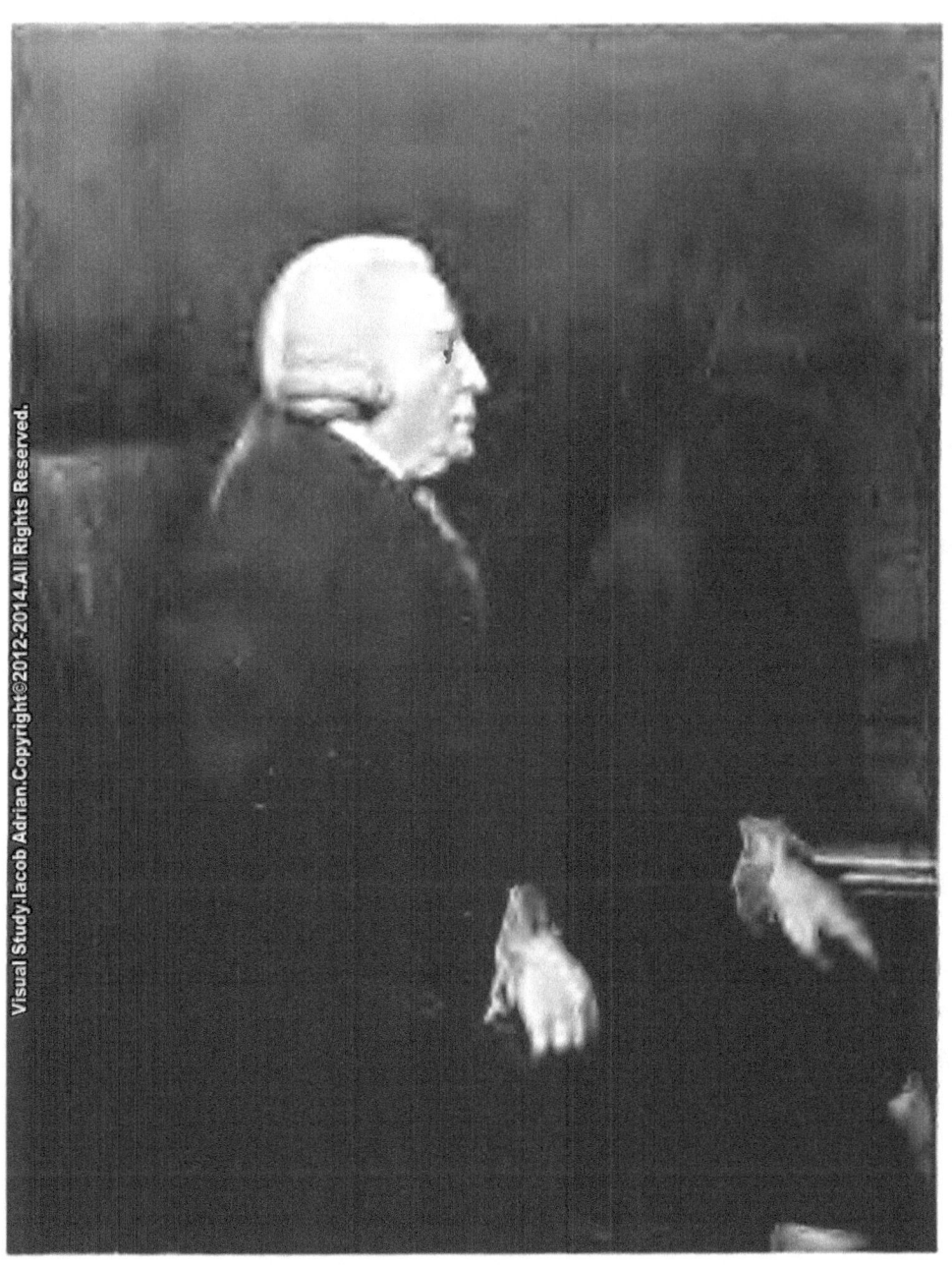

RICHARD CUMBERLAND
(*National Portrait Gallery, London*)
W. A. Mansell & Co., Photo.

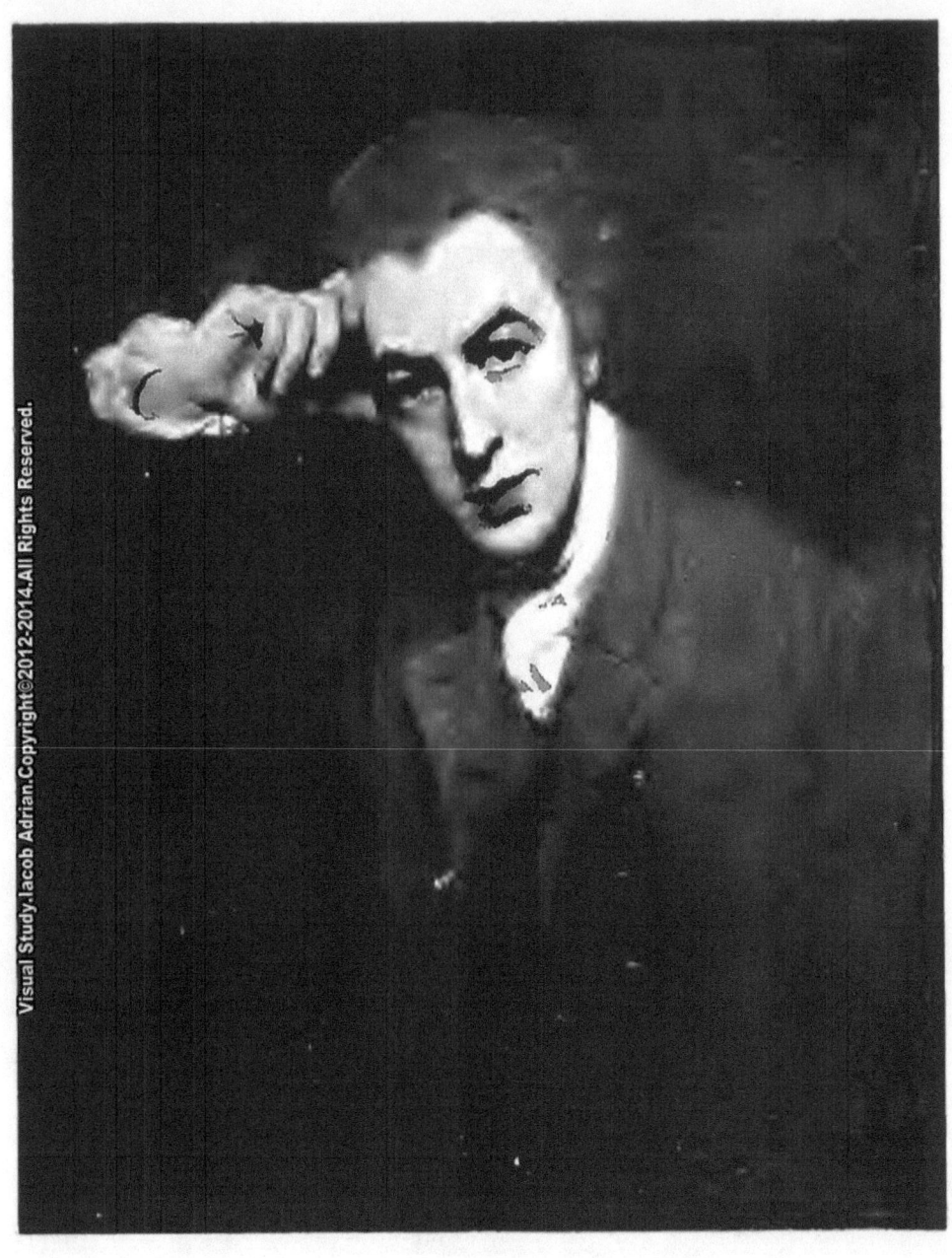

WILLIAM HAYLEY
(*Mr. C. Fairfax Murray, London*)
Braun, Clément & Cie, Photo.

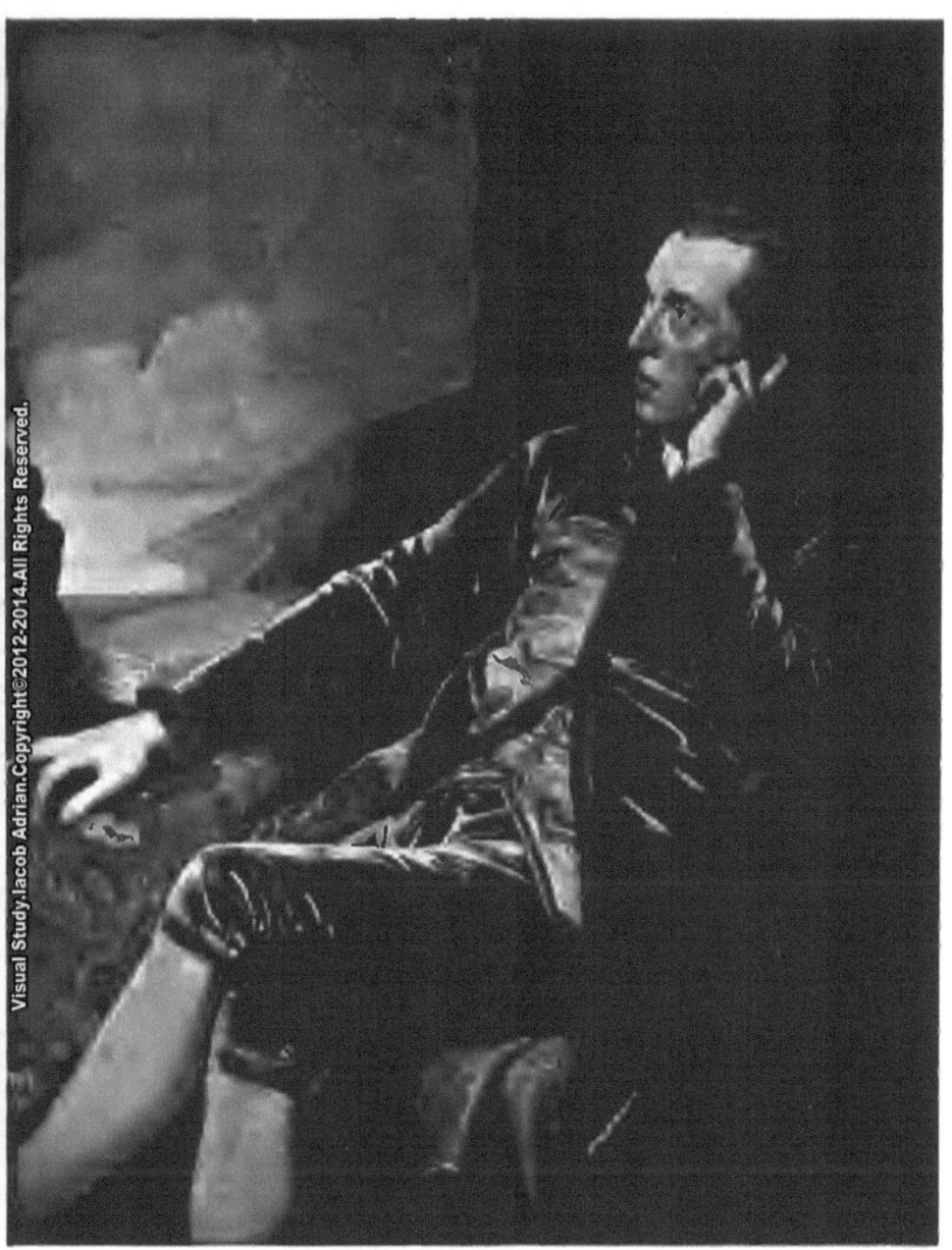

JAMES HARRIS
(*National Portrait Gallery, London*)
W. A. Mansell & Co., Photo.

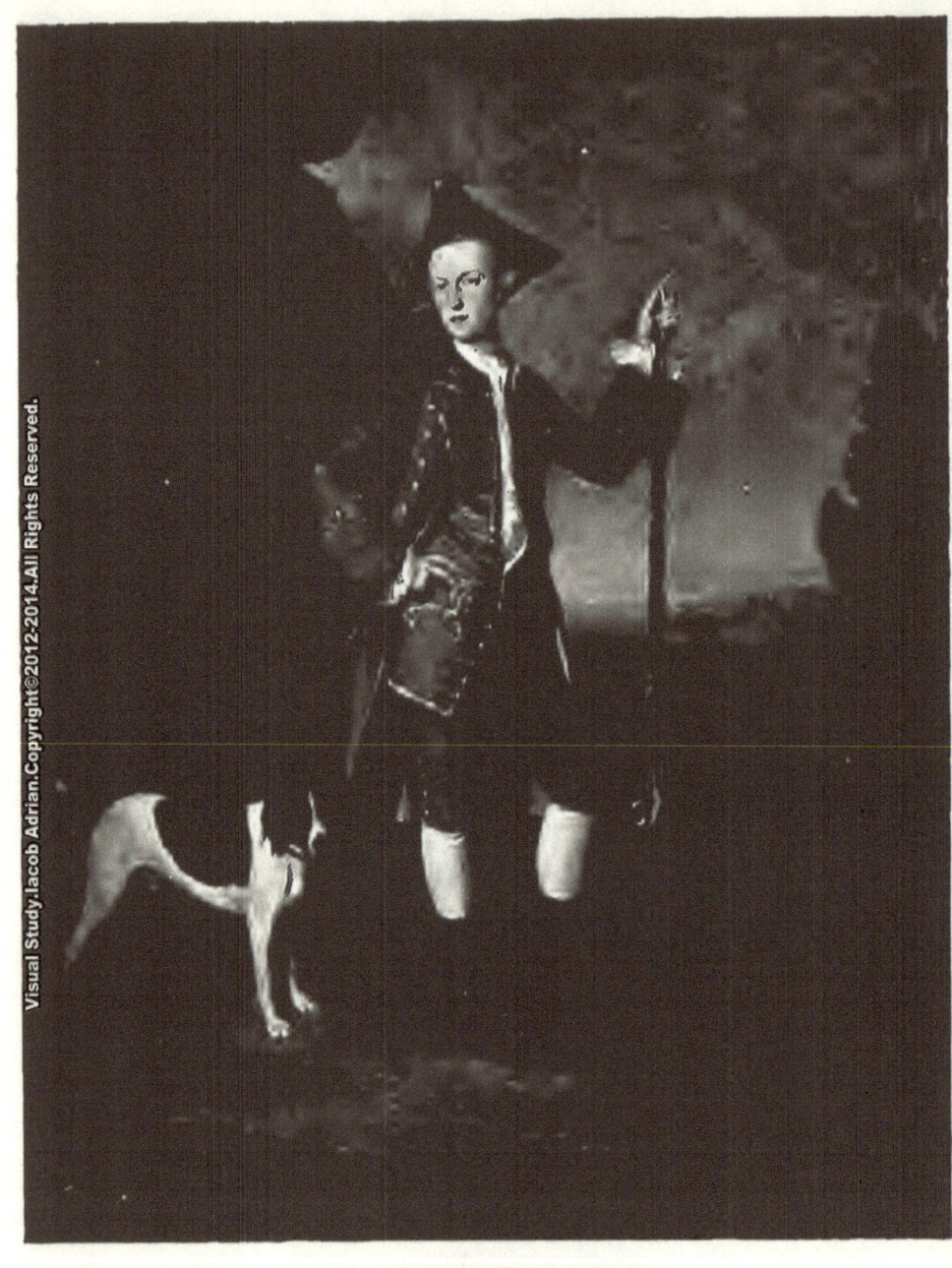

JACOB MORLAND
(*National Gallery, London*)
F. Hanfstaengl, Photo.

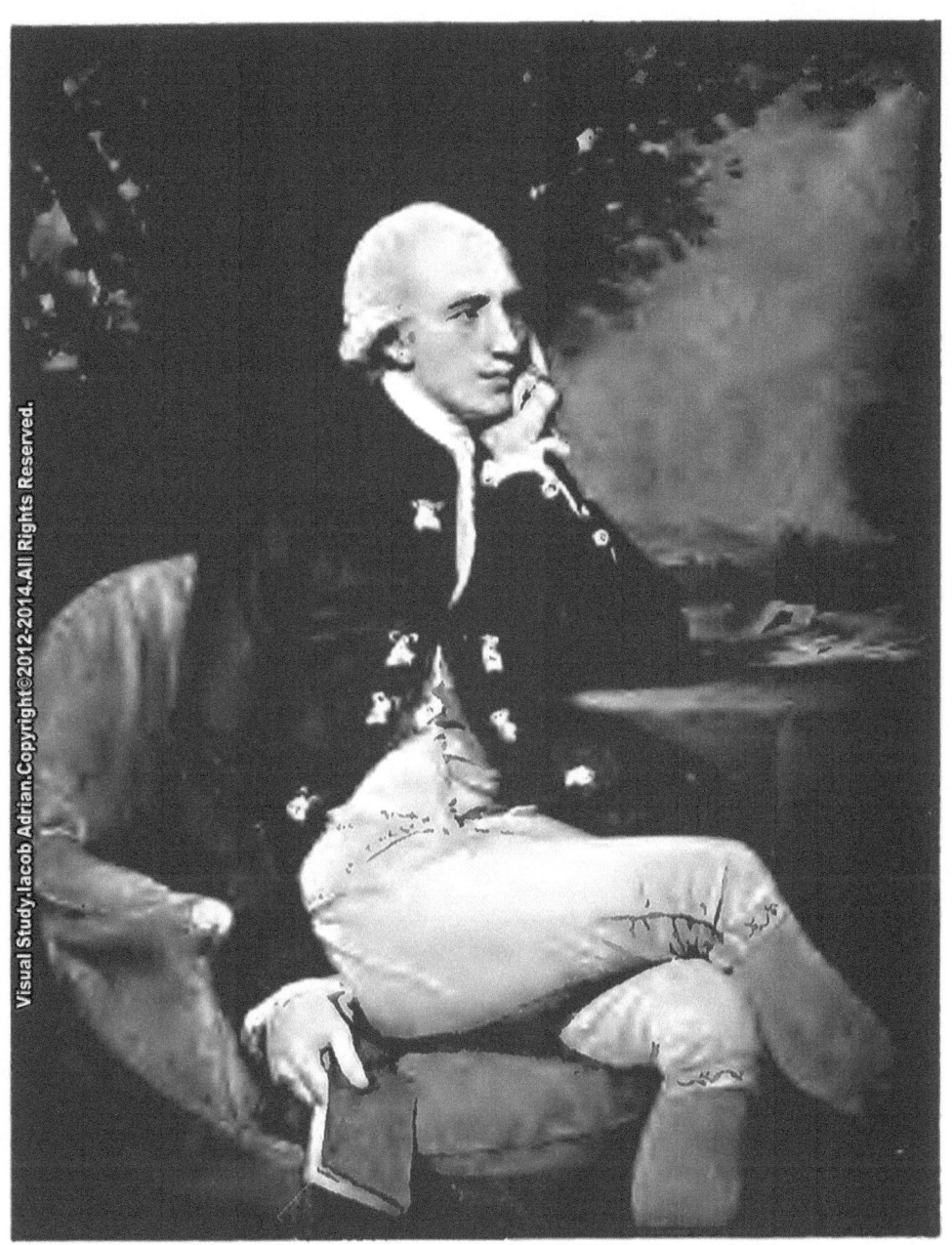

WILLIAM PETRIE, M.P.
(Mr. P. A. B. Widener, Philadelphia)
Braun, Clément & Cie, Photo.

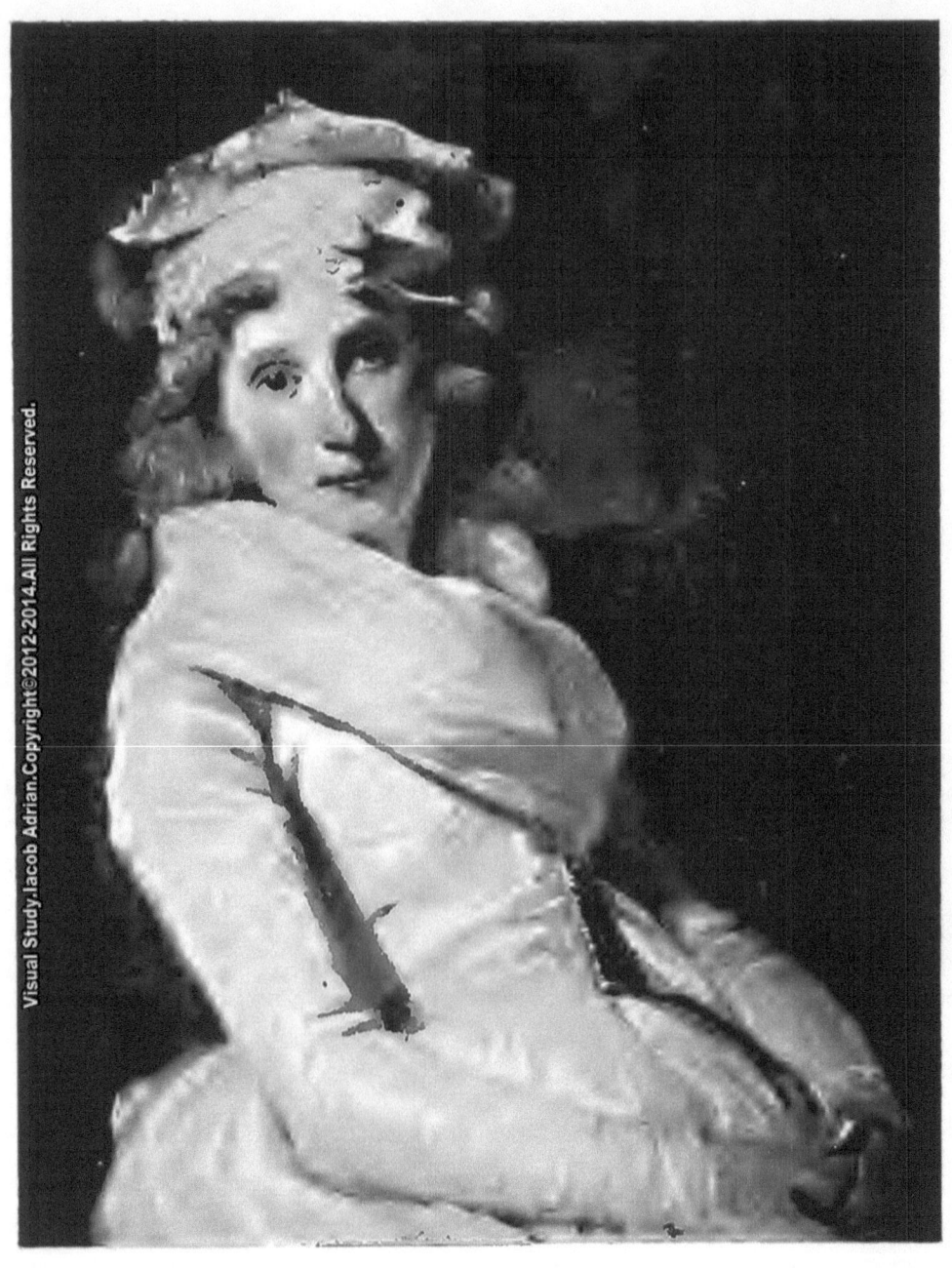

Mrs. Inchbald
(*Sir Edward Tennant, Bart., London*)
W. A. Mansell & Co., Photo.

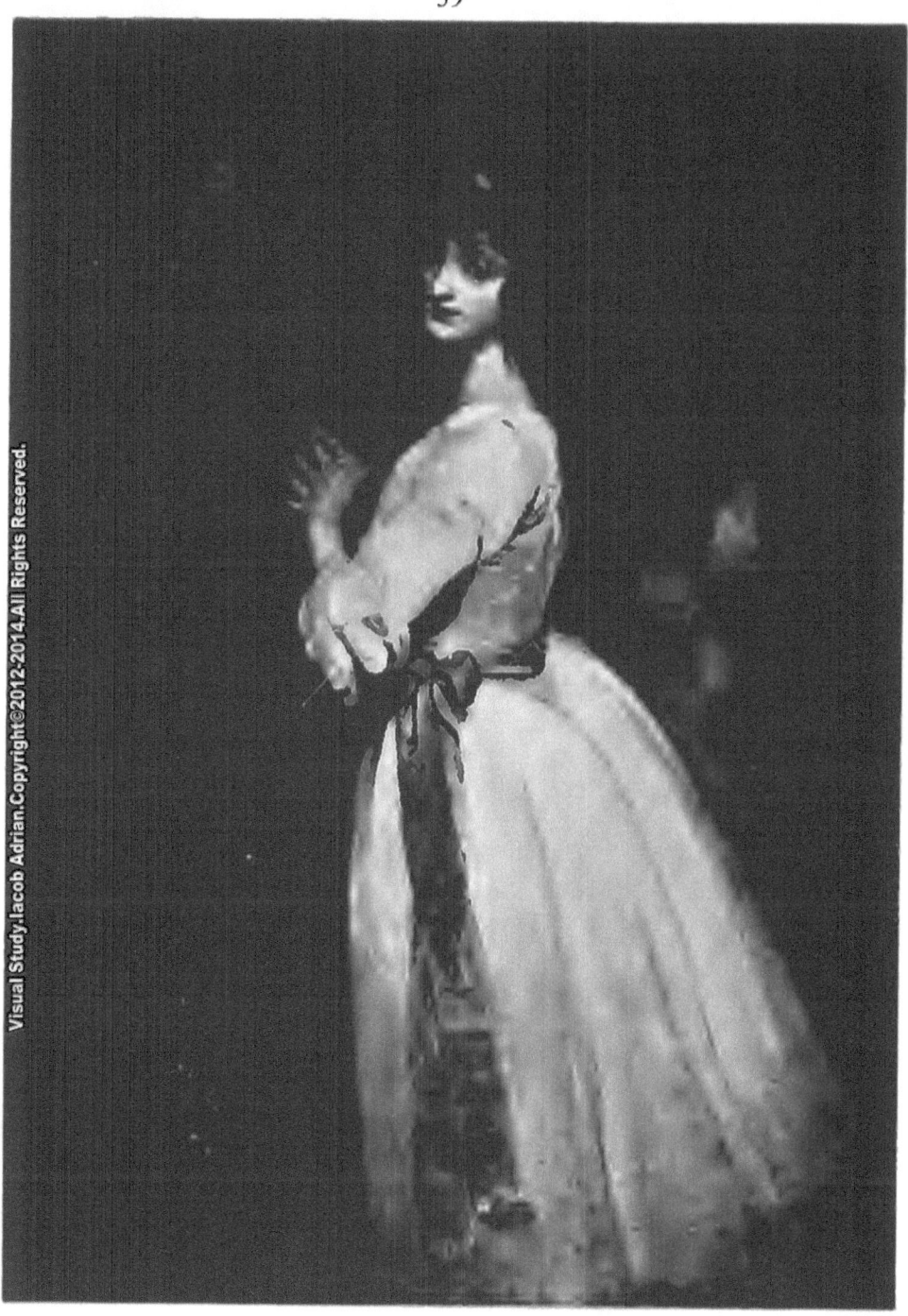

MRS. JORDAN
(*Sir Edward Tennant, Bart., London*)
W. A. Mansell & Co., Photo.

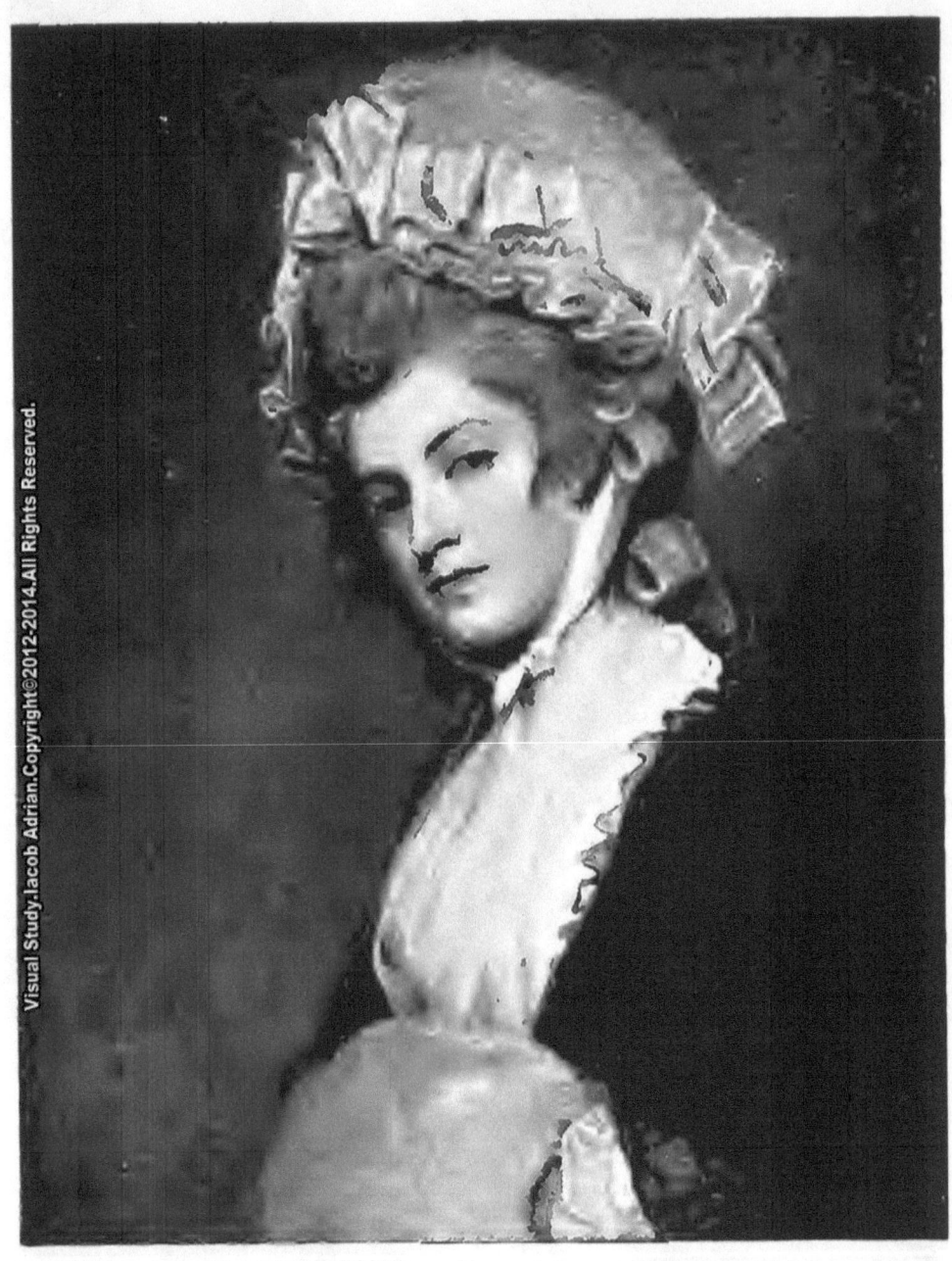

Mrs. Robinson ("Perdita")
(*Wallace Collection, London*)
F. Hanfstaengl, Photo.

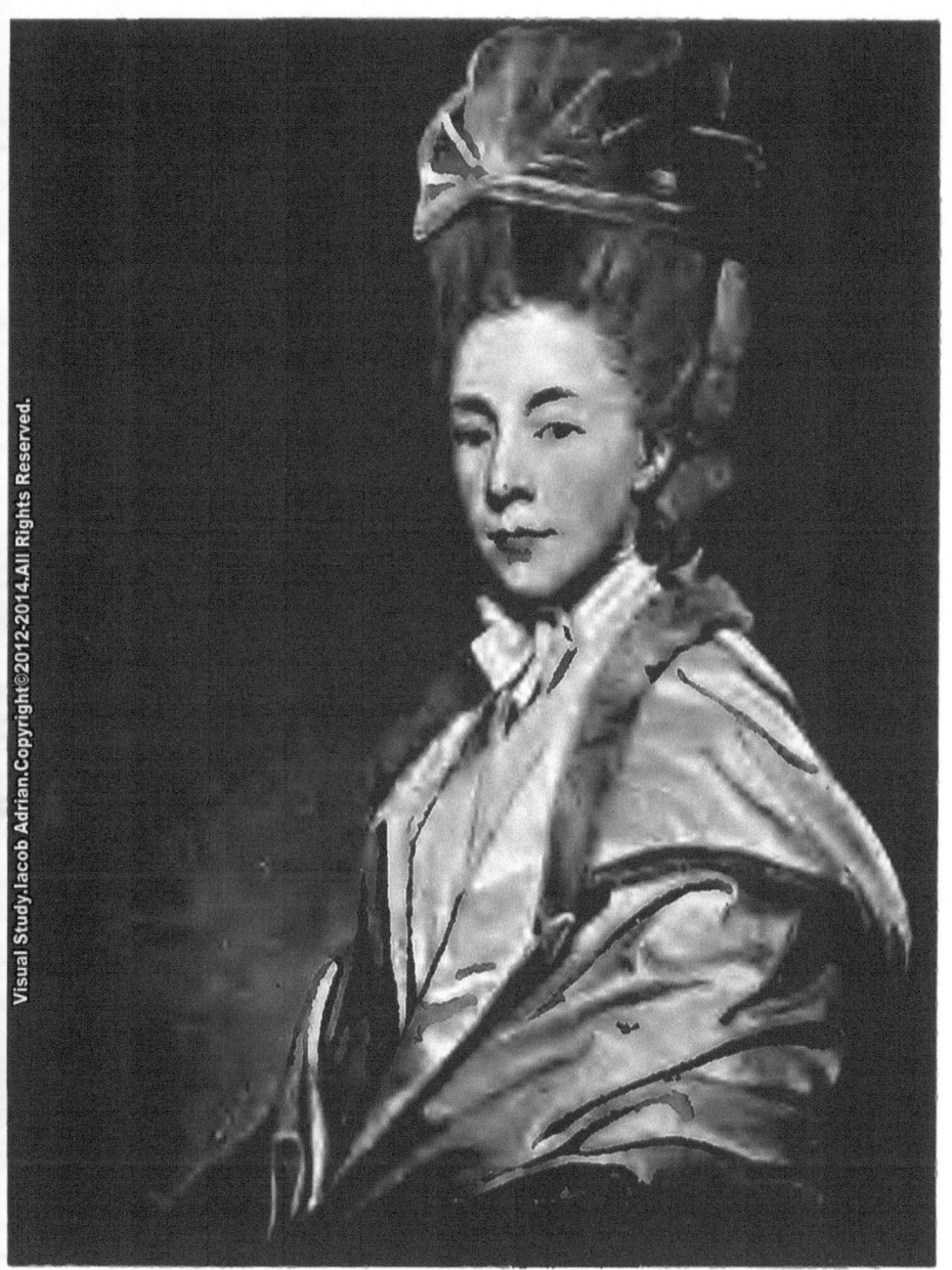

MRS. DAWKES (MRS. ROBINSON)
(Messrs. Thos. Agnew & Sons, London)

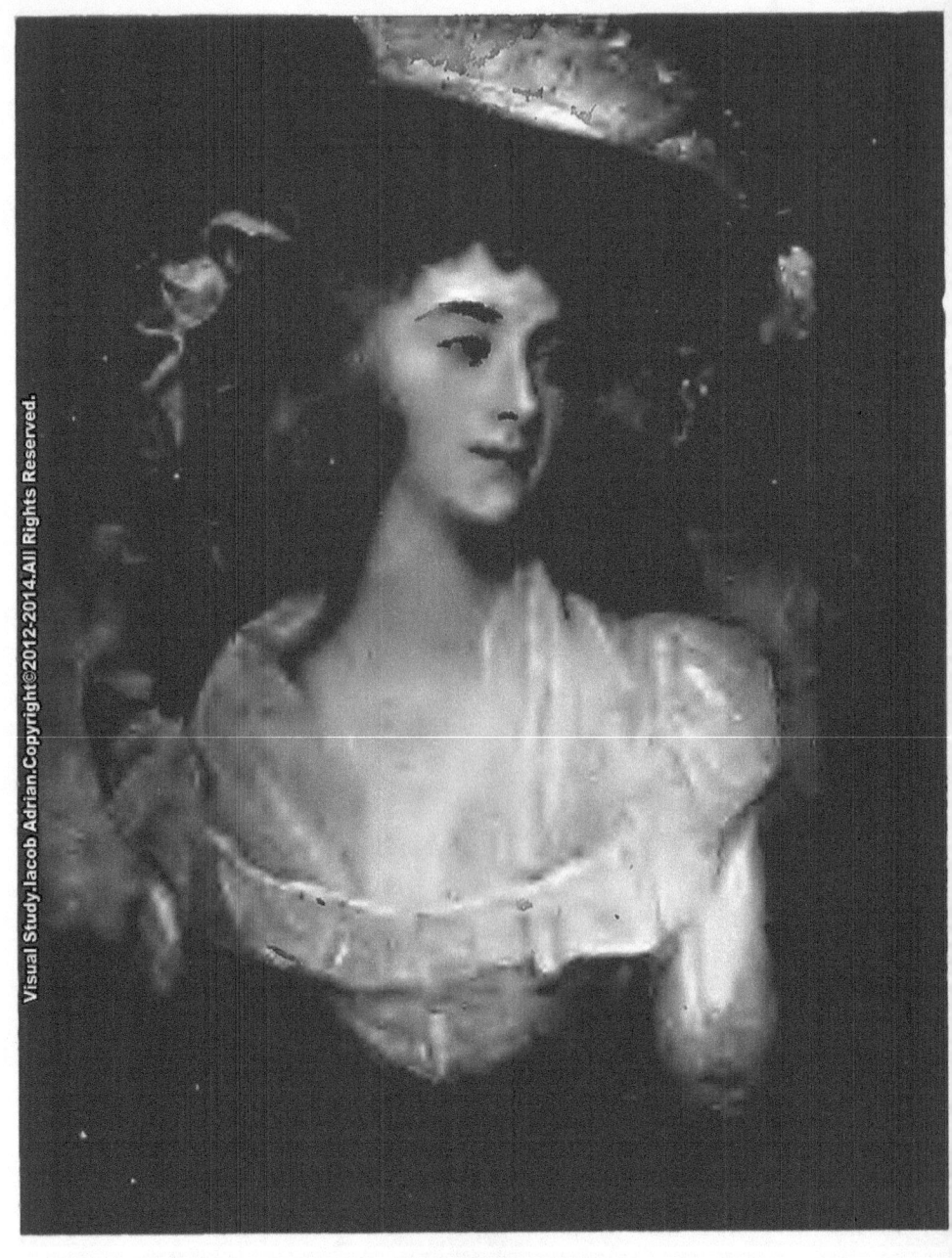

MRS. TICKELL
(*Mr. Alfred de Rothschild, London*)
Braun, Clément & Cie, Photo.

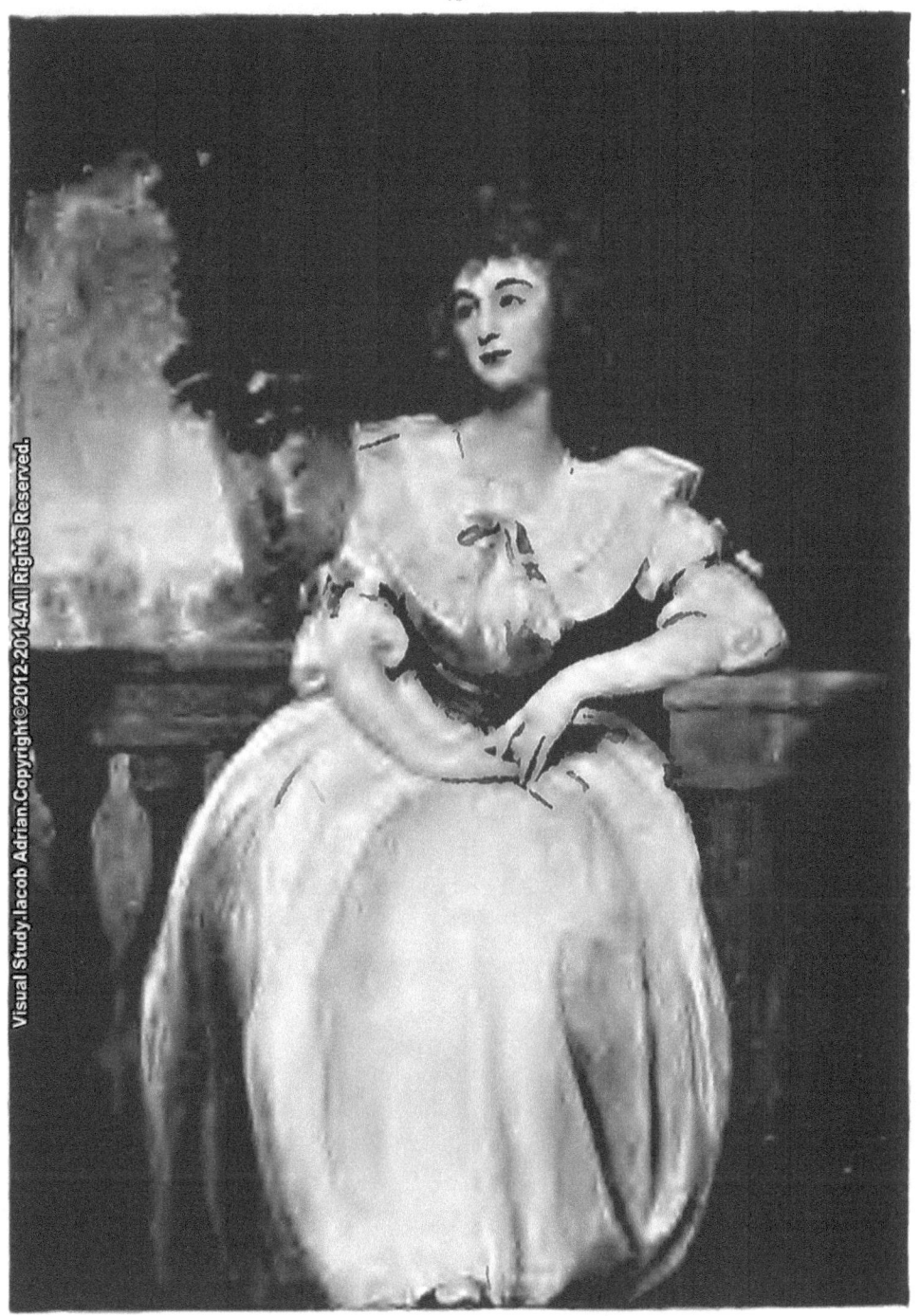

MRS. MARK CURRIE
(National Gallery, London)
F. Hanfstaengl, Photo.

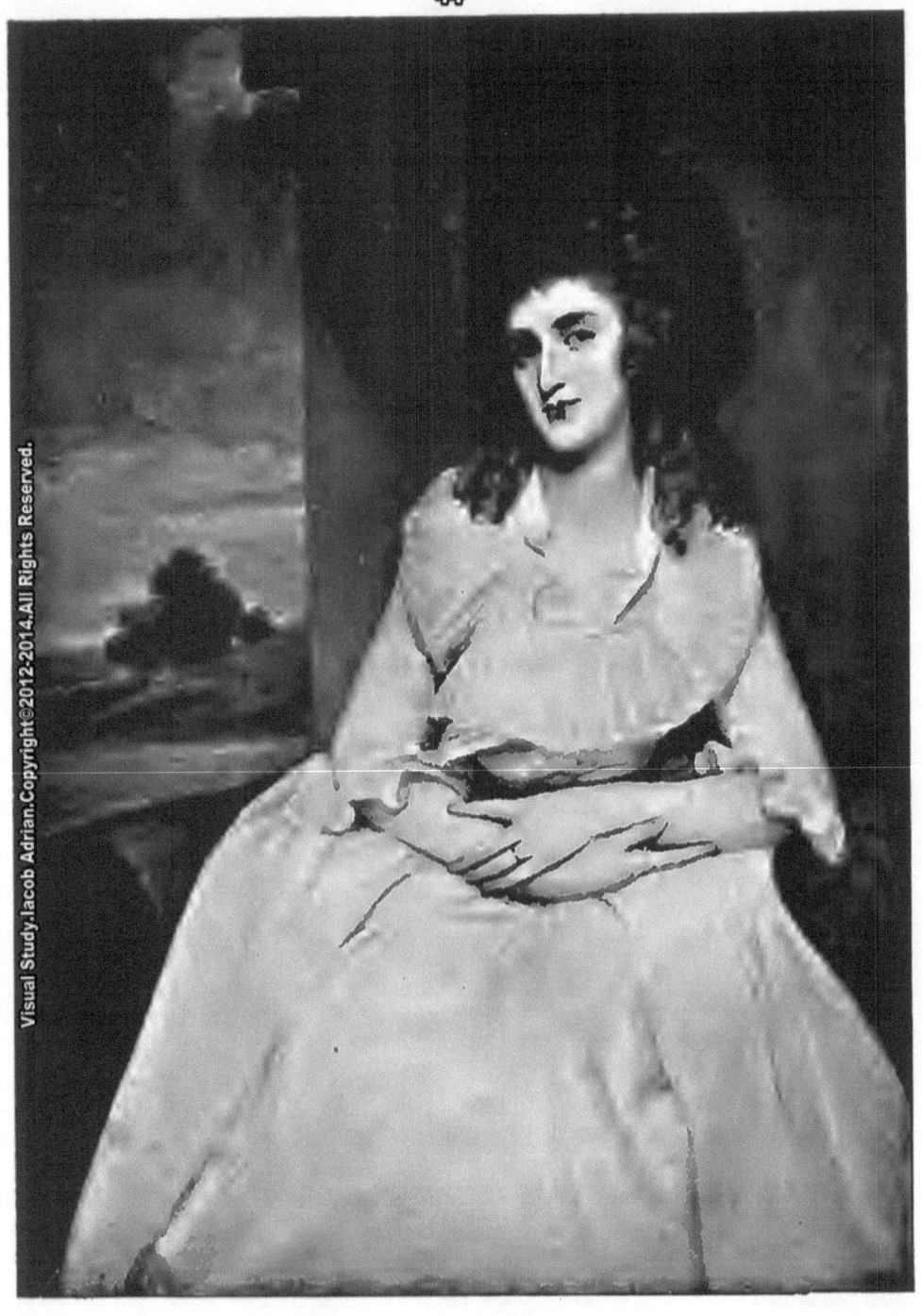

MRS. MINGAY
(*M. Charles Sedelmeyer, Paris*)
Braun, Clément & Cie, Photo.

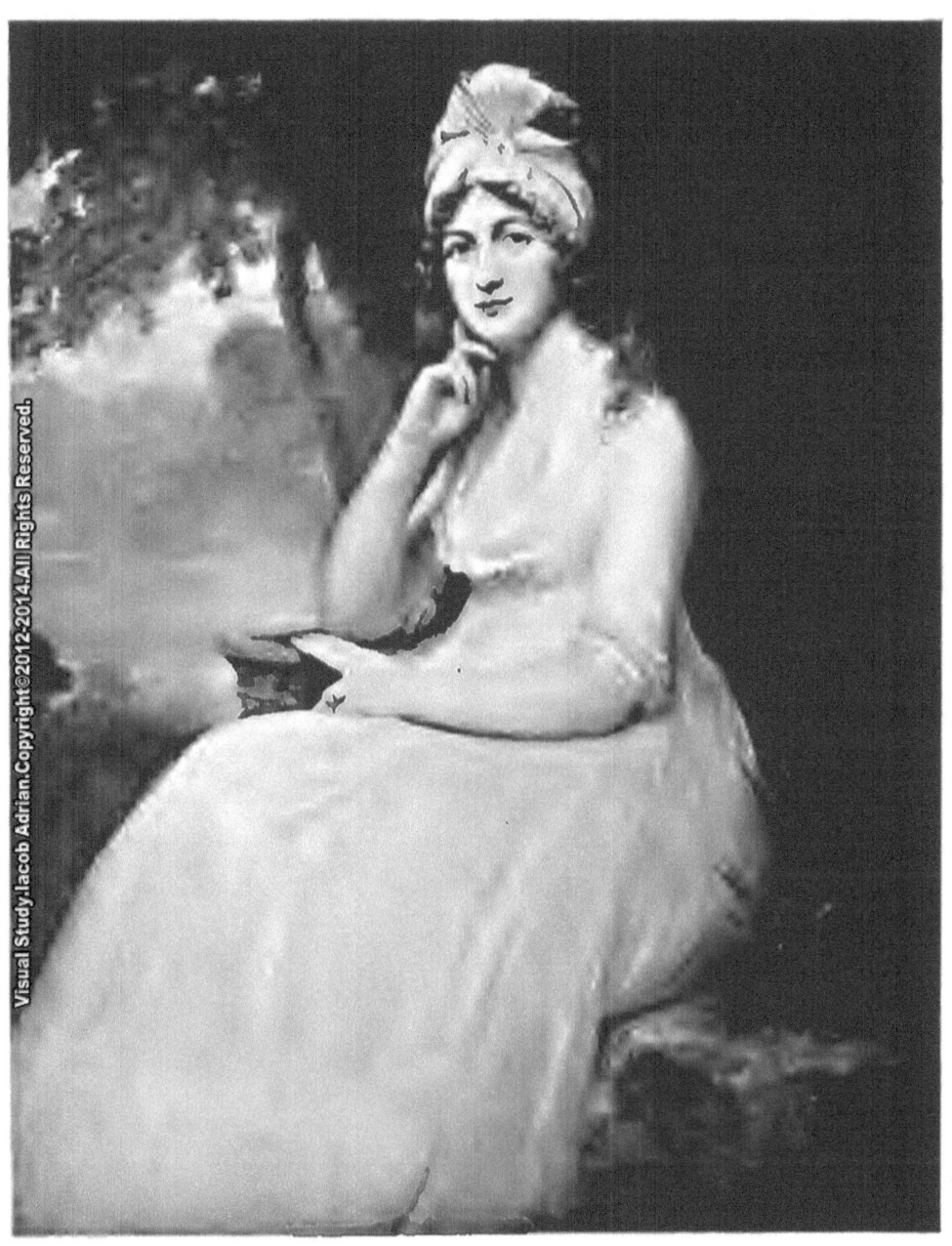

MRS. CHARNOCK
(M. Charles Sedelmeyer, Paris)
Braun, Clément & Cie, Photo.

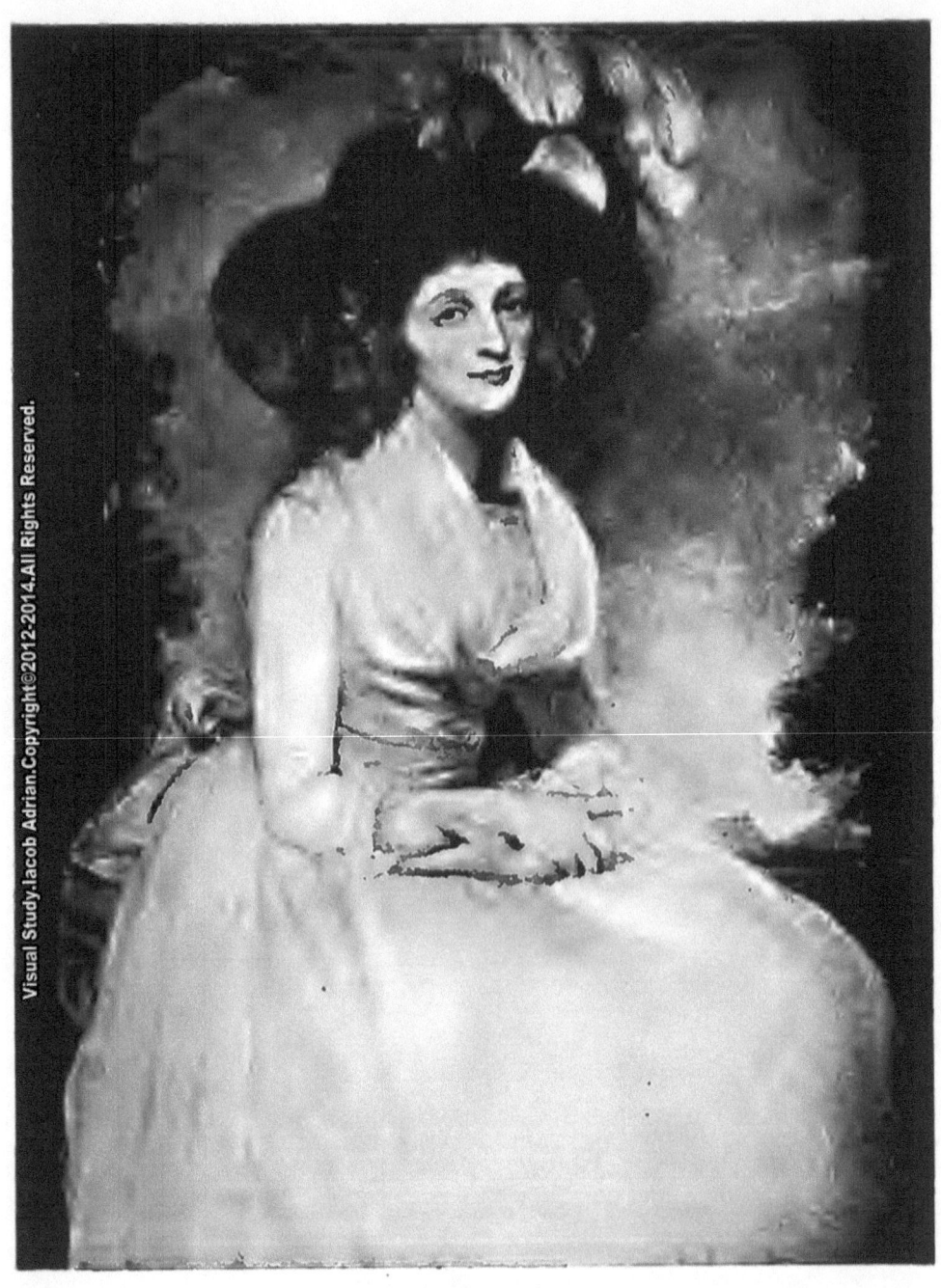

MRS. GROVE
(*Mr. E. R. Bacon, New York*)

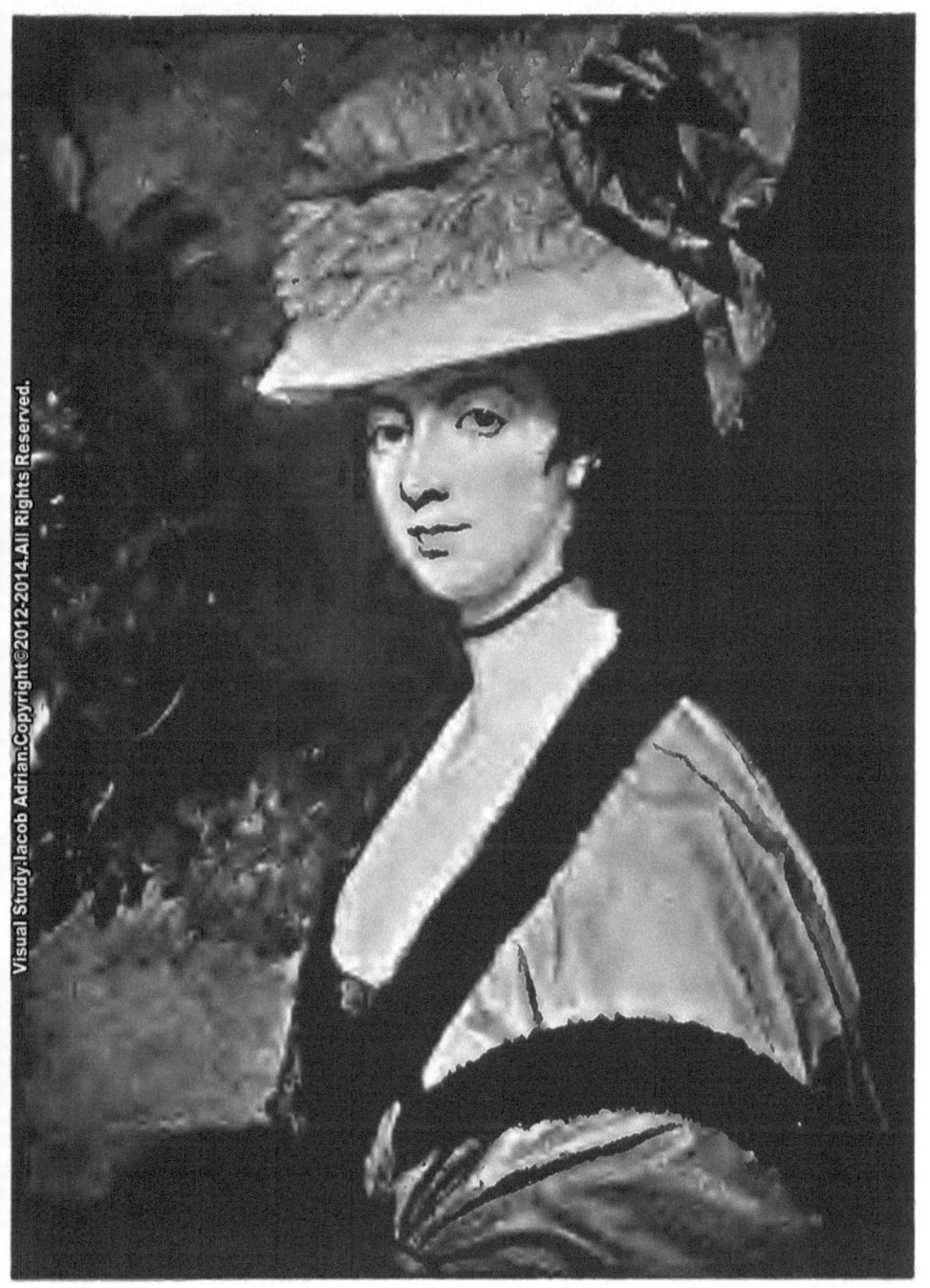

MRS. ELIZABETH GROVE

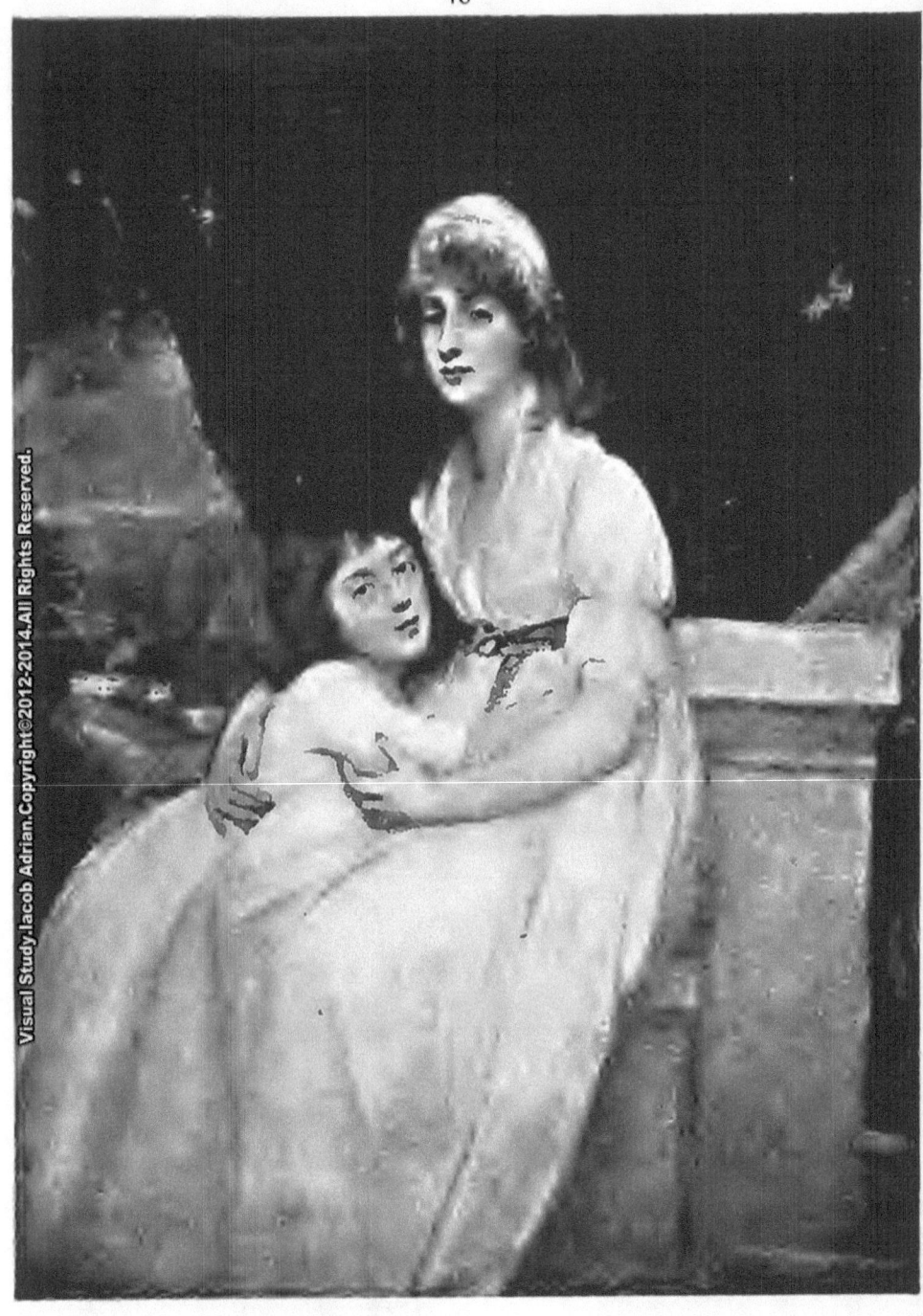

Mrs. Morton Pitt and Daughter

Mme Morton Pitt et sa Fille

Frau Morton Pitt und ihre Tochter

(*M. F. Bischoffsheim, Paris*)

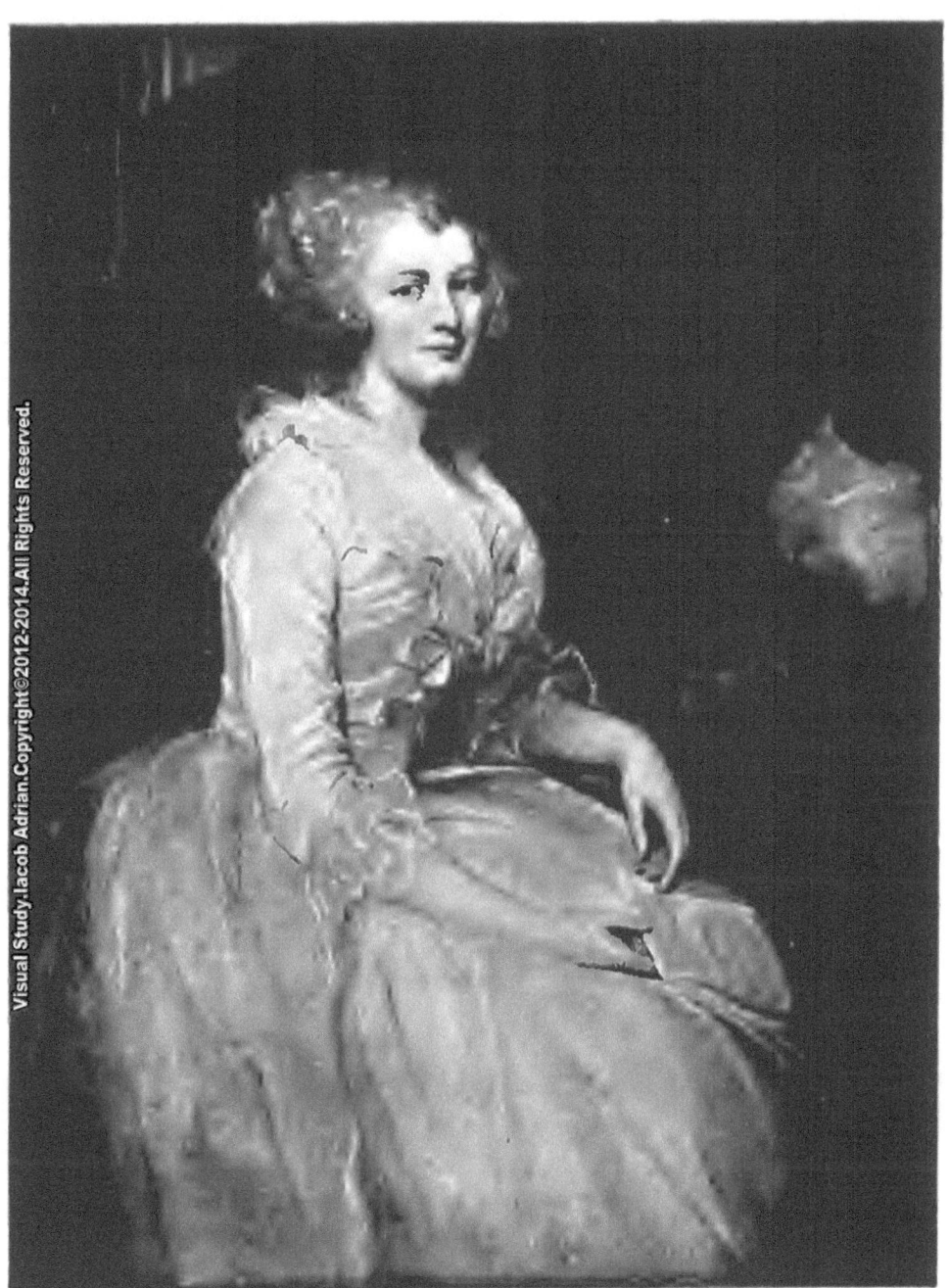

MRS. BLAIR
(*Mr. P. A. B. Widener, Philadelphia*)

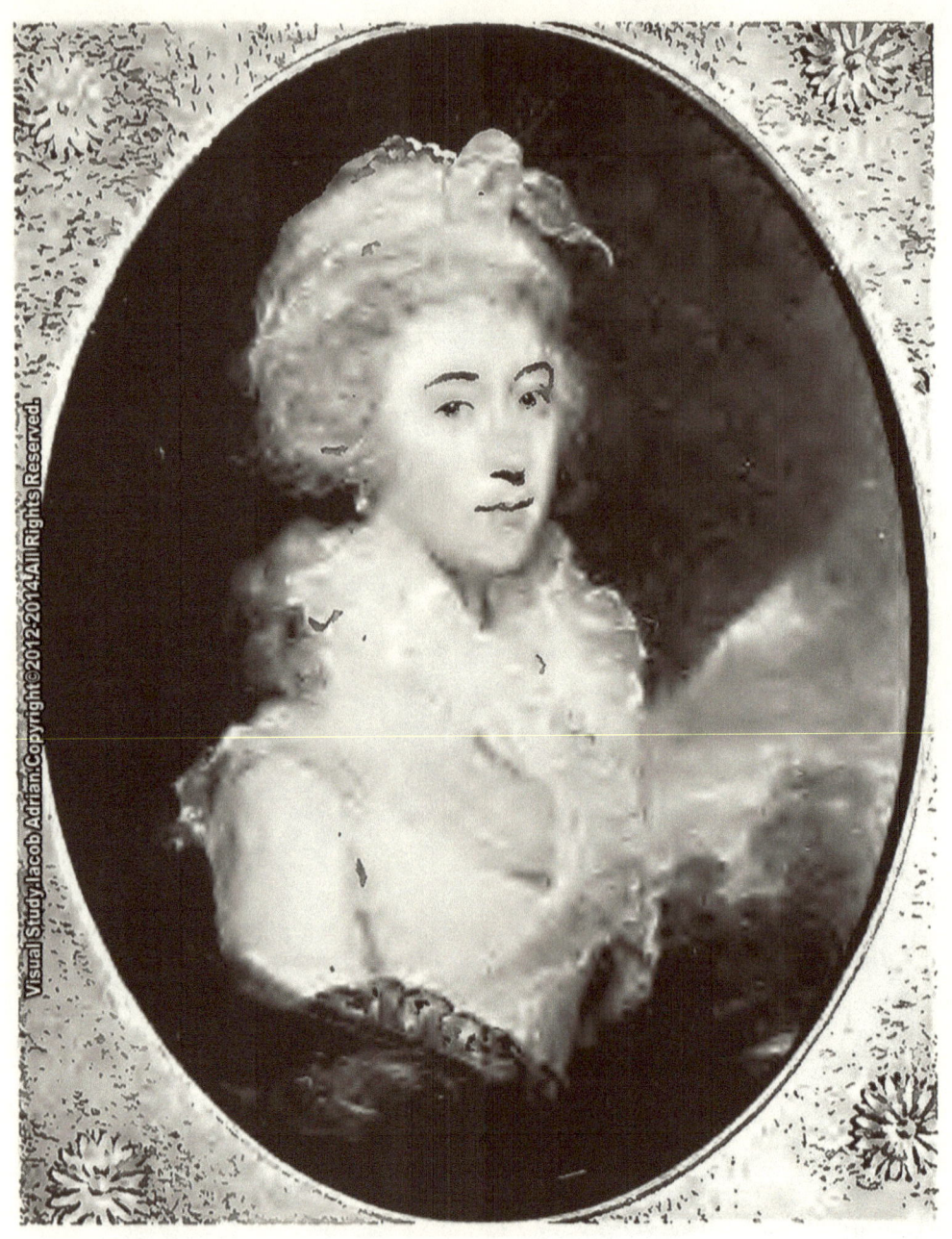

MISS HARRIET PARRY
(*Sir Hubert Parry, Highnam*)
W. A. Mansell & Co., Photo.

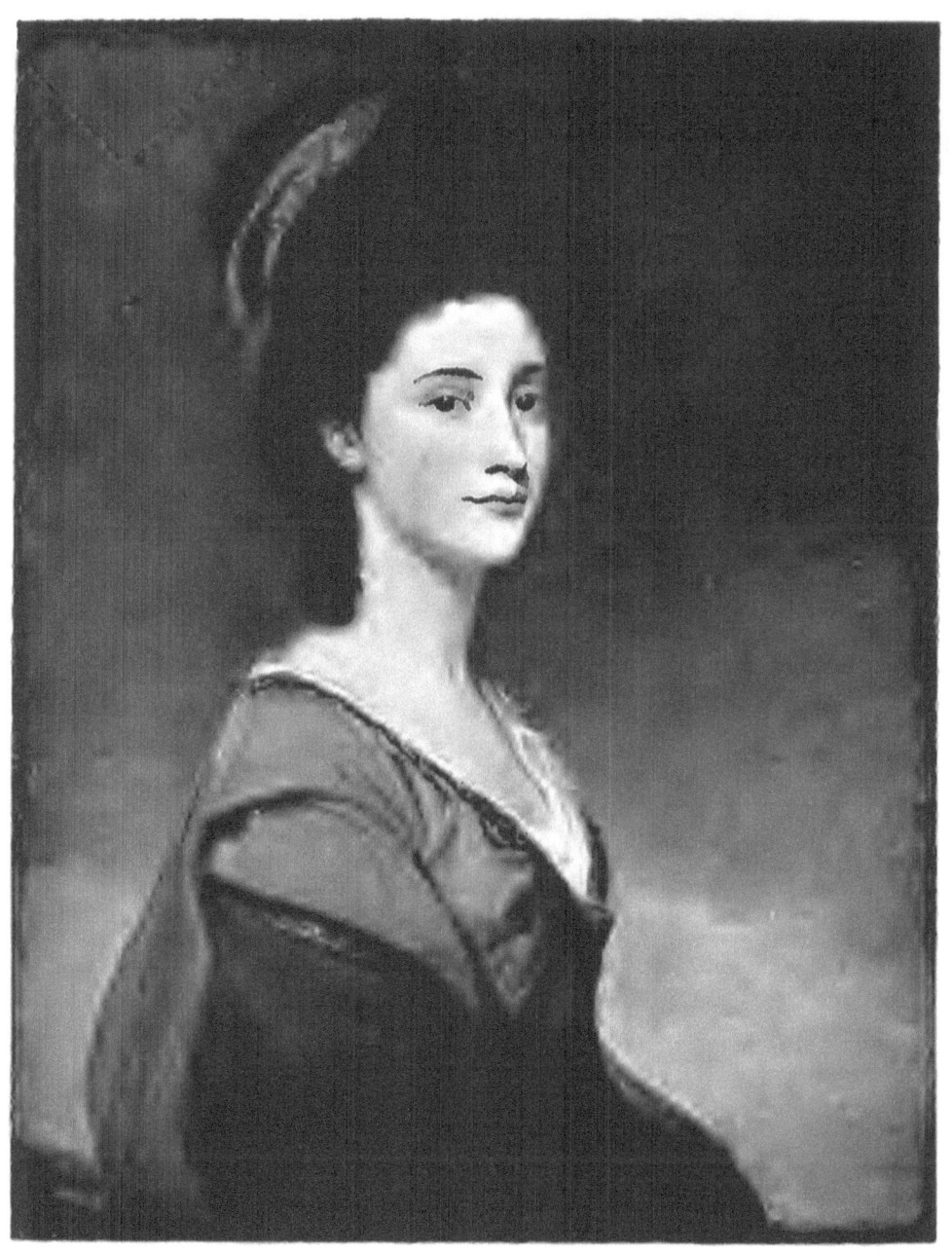

Miss Ramus
(Hon. W. F. D. Smith)
F. Hanfstaengl, Photo.

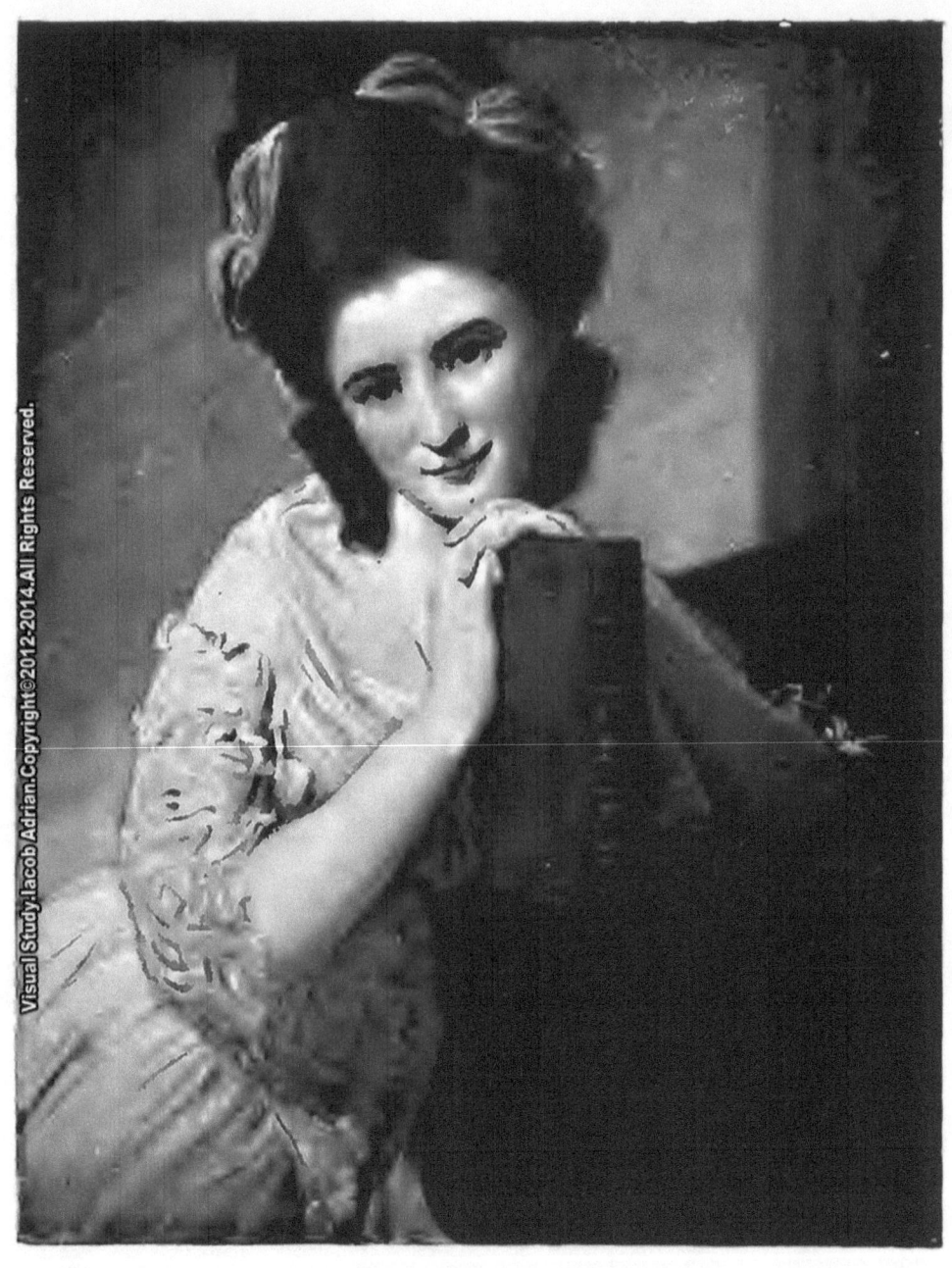

MISS BENEDETTA RAMUS
(*Hon. W. F. D. Smith*)
F. Hanfstaengl, Photo.

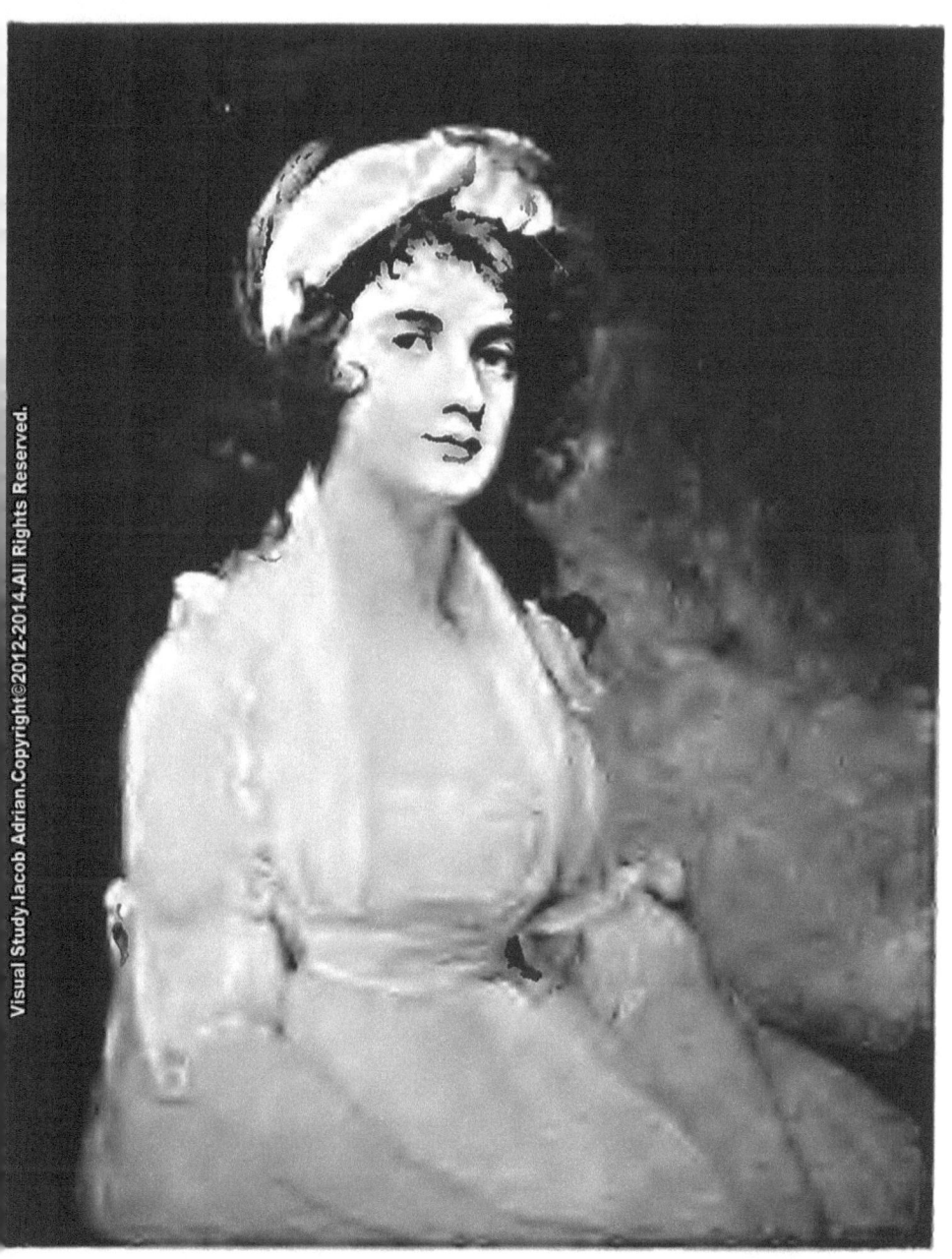

MISS TIGHE
(*M. Charles Sedelmeyer, Paris*)
Braun, Clément & Cie, Photo.

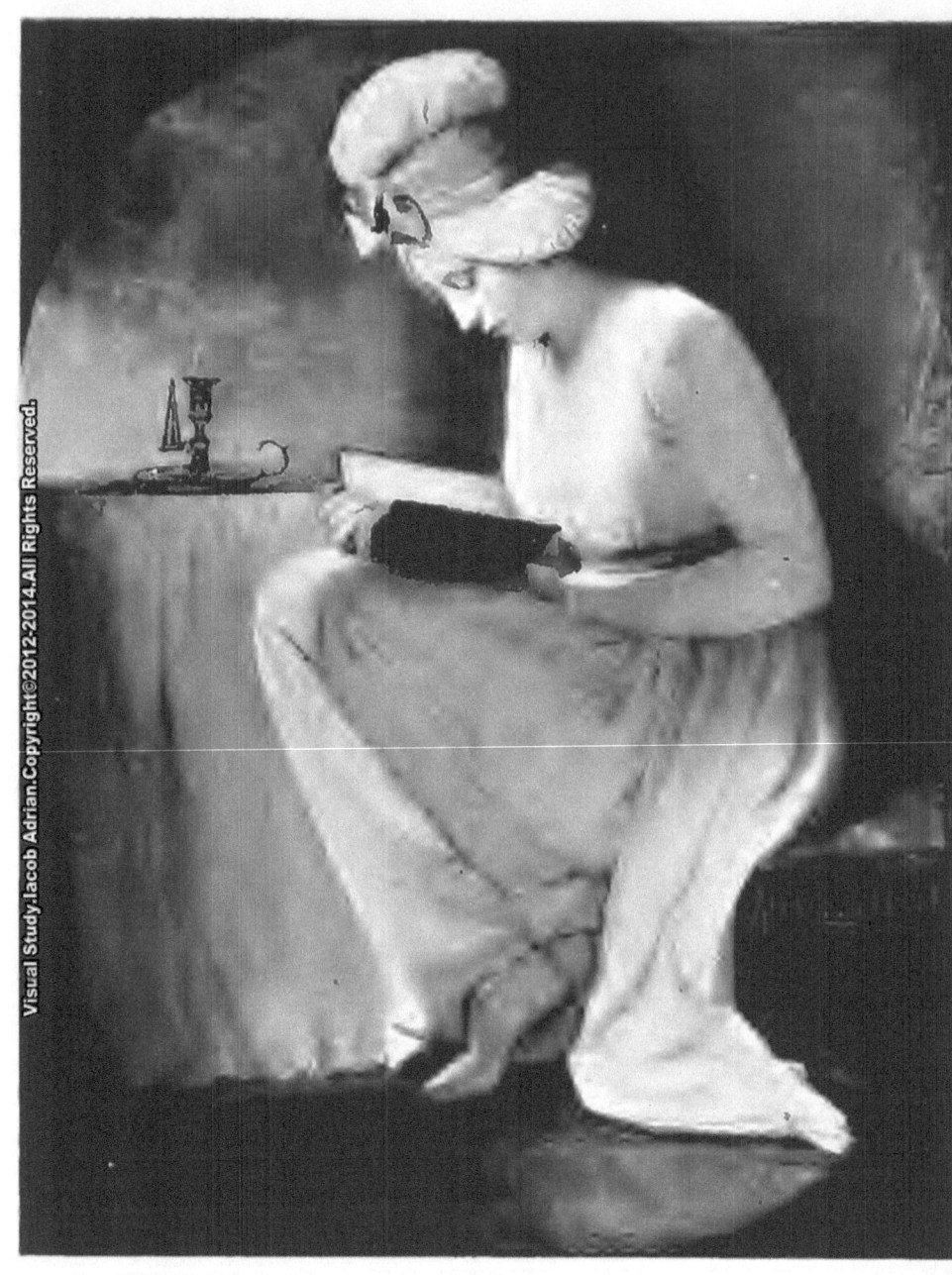

MISS SNEYD ("SERENA")
(*Duke of Sutherland, London*)
E. *Harrison & Son, Photo.*

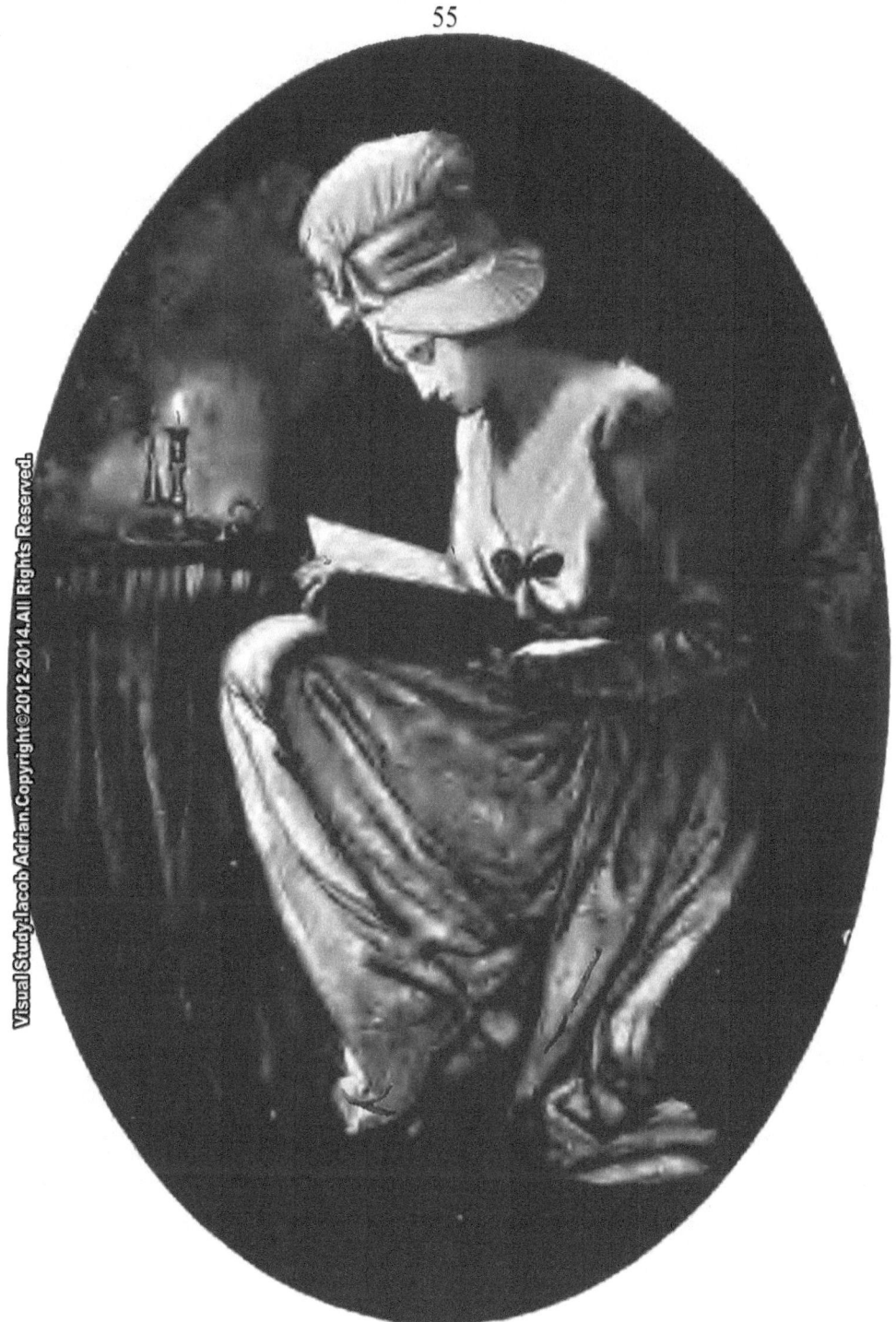

Miss Sneyd ("Serena")
(South Kensington Museum, London)
W. A. Mansell & Co., Photo.

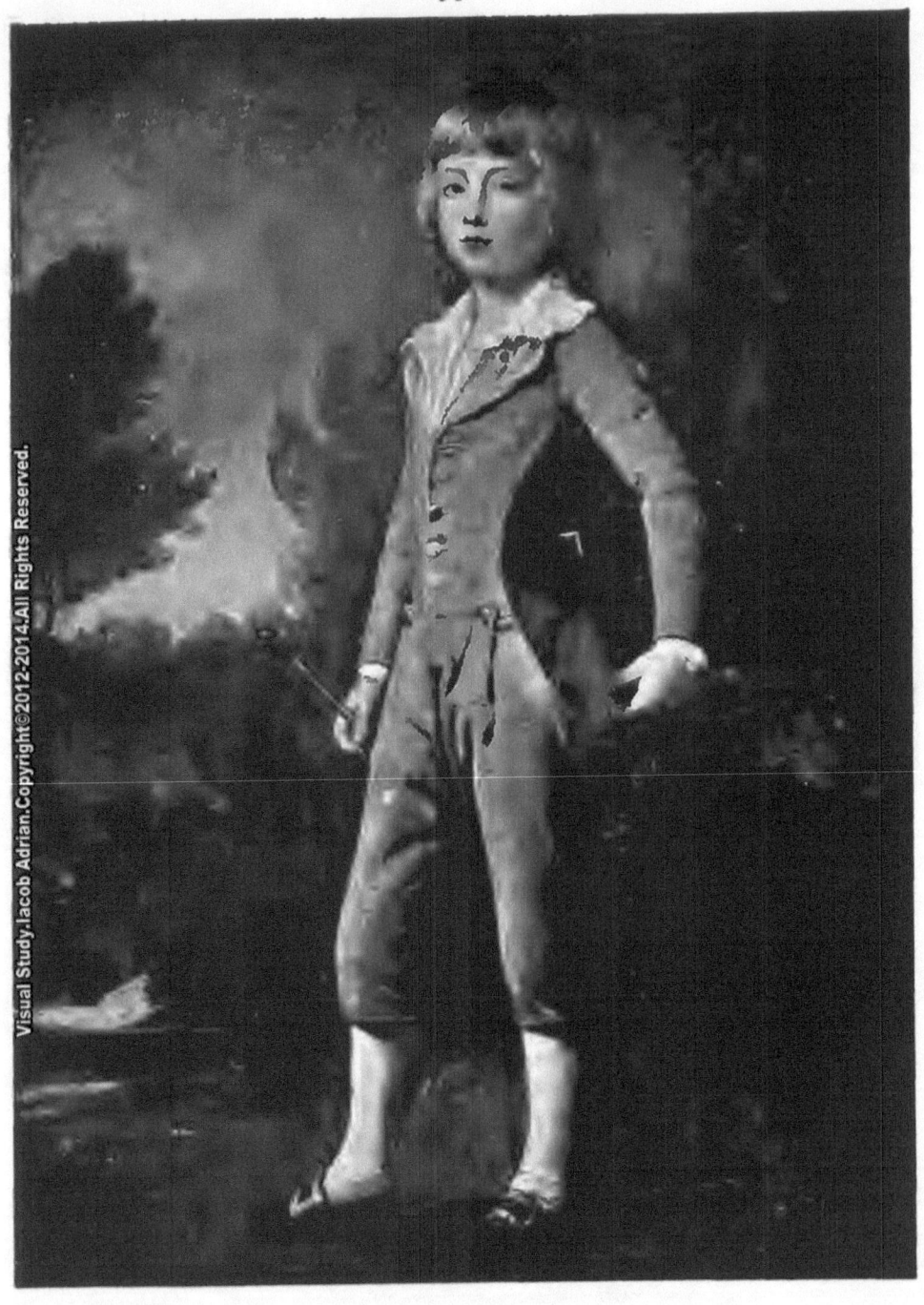

THE BLUE BOY (MASTER LUSHINGTON) LE GARÇON BLEU
DER BLAUE KNABE
(Mrs. Lubbock, Byfleet)
W. A. Mansell & Co., Photo.

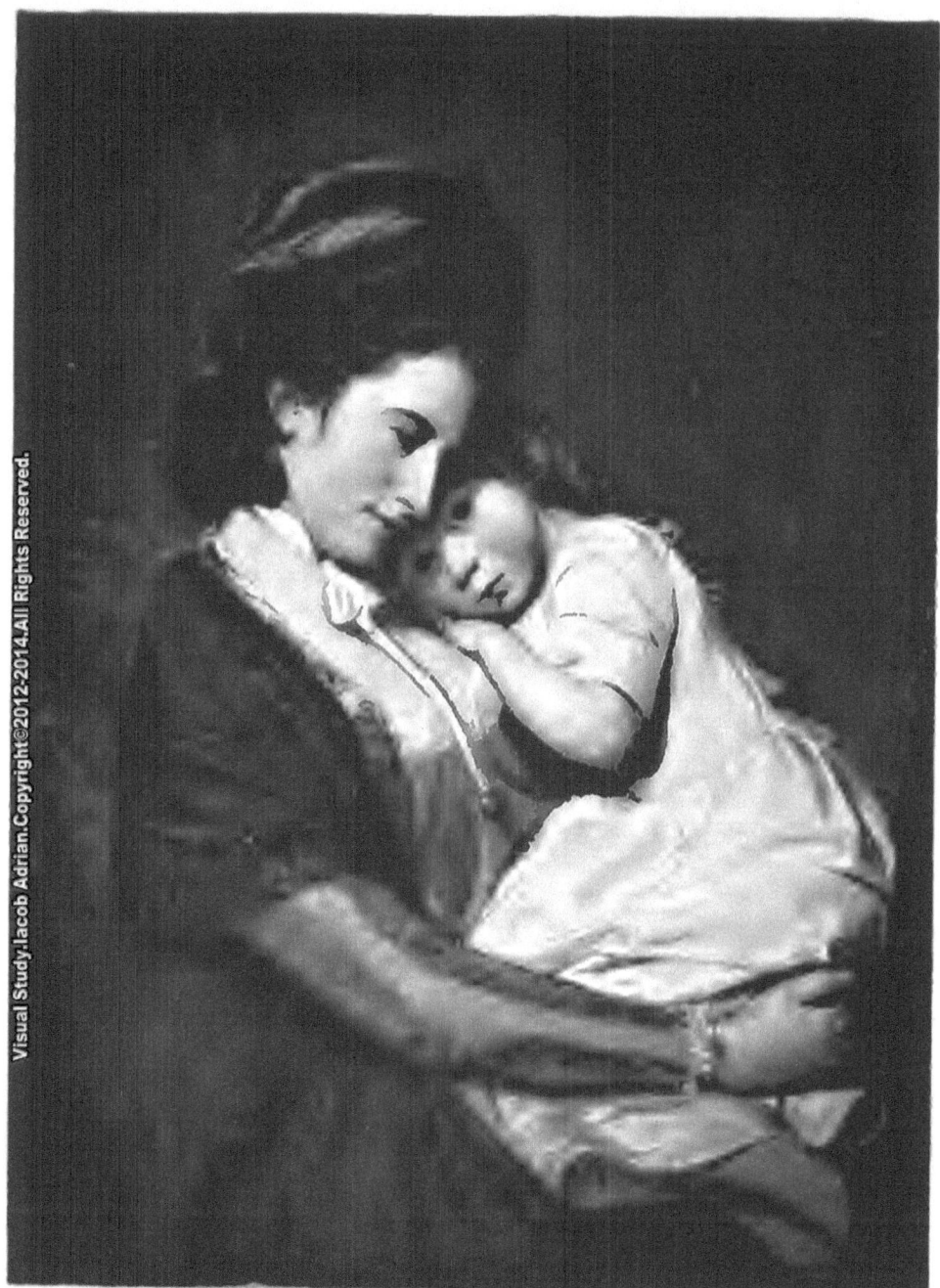

A Lady (Mrs Ford?) and her Child
(National Gallery, London)

Une Dame (Mme Ford?) et son Enfant
(Galerie nationale, Londres)

Eine Dame (Frau Ford?) und sein Kind
(London, Nationalgalerie) F. Hanfstaengl, Photo.

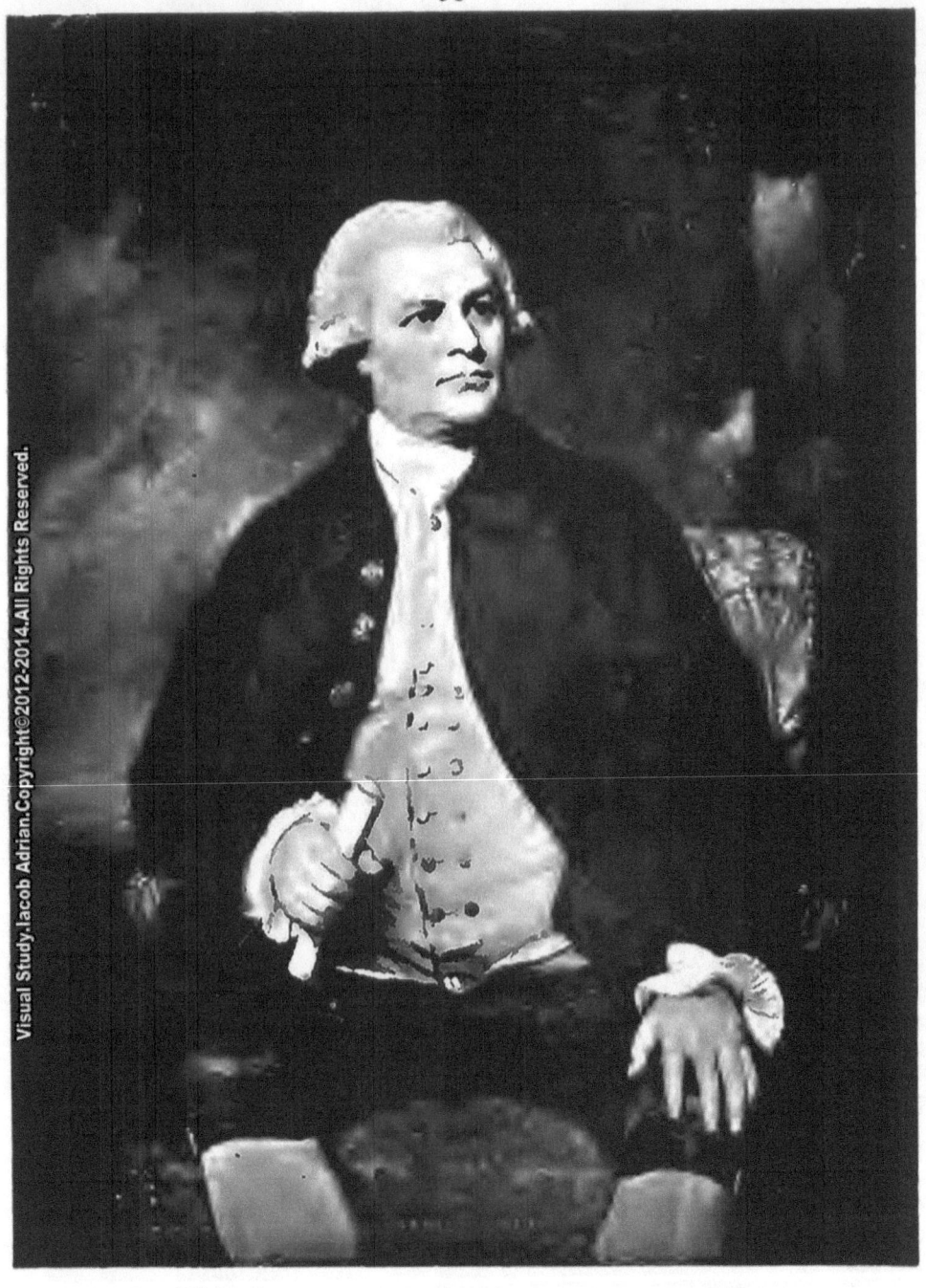

PORTRAIT OF A MAN PORTRAIT D'HOMME
BILDNIS EINES MANNES
(Mme Maurice Kann, Paris)
Braun, Clément & Cie, Photo.

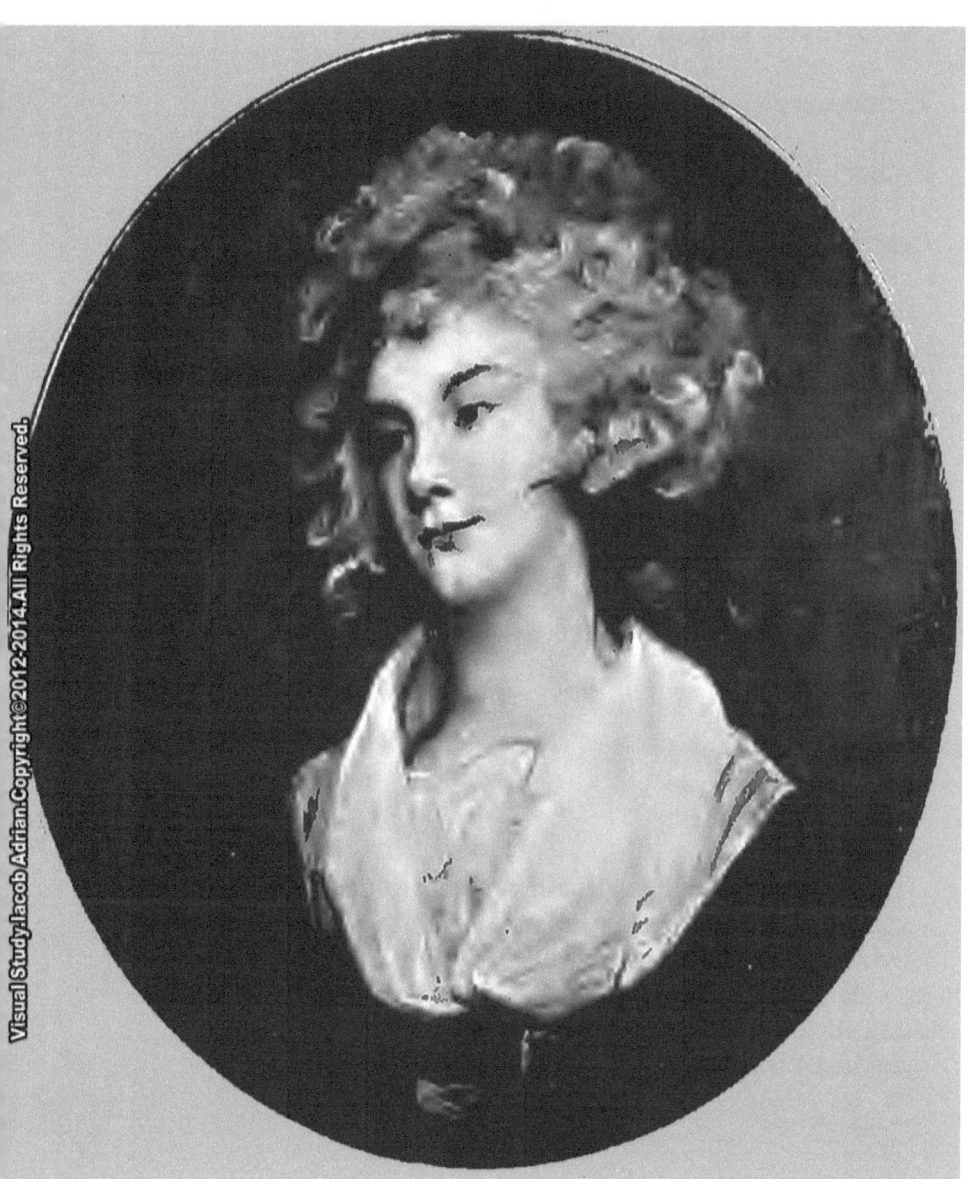

THE PARSON'S DAUGHTER
(National Gallery, London)

LA FILLE DU PASTEUR
(Galerie nationale, Londres)

DIE PFARRERSTOCHTER
(London, Nationalgalerie)

F. Hanfstaengl, Photo.

Bibliographic sources :

The masterpieces of Romney, 1734-1802 (1910)

Author: Romney, George, 1734-1802

Publisher: London, Gowans & Gray

This documentary study use,
combined in various proportions,
elements from the following categories,
forms and subsets :
- fair use
- documentary
- documentary photography
- feature
- journalism
- arts journalism
- visual journalism
- photojournalism
- celebrity photography
in order to :
- employ material as the object of cultural critique ,
- quote to illustrate an argument or point ,
- use material in historical sequence,
providing independent opinion,
using photos, press articles, advertisements,
opinions of fans etc. ...

Copyright©2012-2014 Iacob Adrian
All Rights Reserved.

www.ingramcontent.com/pod-product-compliance
Lightning Source LLC
Chambersburg PA
CBHW021022180526
45163CB00005B/2073